kimonos

magali veillon *Project Manager, English-language edition*

beverly herter *Editor, English-language edition*

e.y. lee *Designer, English-language edition*

e.y. lee *Jacket design, English-language edition*

tina cameron *Production Manager, English-language edition*

Library of Congress Cataloging-in-Publication Data

Milenovich, Sophie.
 [Kimonos. English]
 Kimonos / by Sophie Milenovich ; translated from the French by Anthony
Roberts.
 p. cm.
 ISBN-13: 978-0-8109-9450-8
 ISBN-10: 0-8109-9450-X
 1. Kimonos–Patterns. 2. Kimonos–Pictorial works. 3.
Kimonos–Japan–History. I. Title.

 TT504.6.J3M55 2007
 391.00952–dc22

 2007022634

Printed and bound in China
10 9 8 7 6 5 4 3 2 1

HNA
harry n. abrams, inc.
a subsidiary of La Martinière Groupe

115 West 18th Street
New York, NY 10011
www.hnabooks.com

kimonos

Abrams, New York

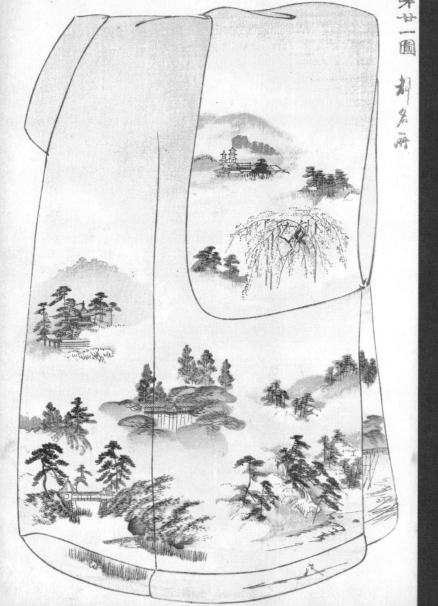

Things That Arouse a Fond Memory of the Past

Dried hollyhock. The objects used during the Display of Dolls. To find a piece of deep violet or
grape-colored material that has been pressed between the pages of a notebook.
It is a rainy day and one is feeling bored. To pass the time, one starts looking through some old papers.
And then one comes across the letters of a man one used to love.
Last year's paper fan. A night with a clear moon.

Sei Shônagon, *The Pillow Book* (c. 996–1002).

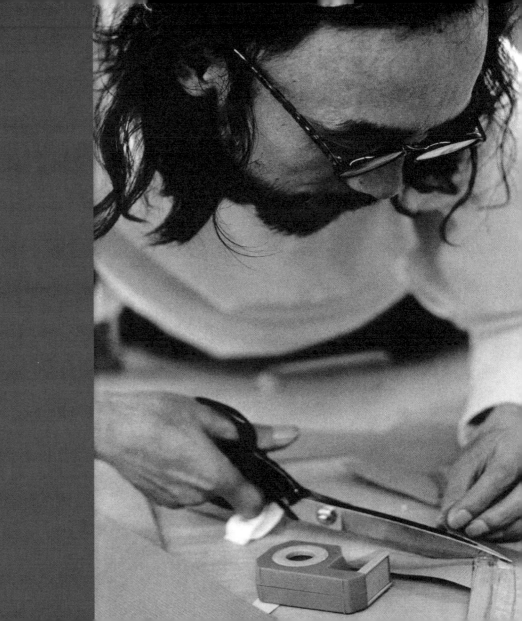

Why did I want to go to Tokyo?

Because of a dress, I think. I had always wanted to understand how the Japanese fashion designer Yohji Yamamoto, a man of a different generation and a very different culture from my own, could know so exactly what I wanted to wear and how to express my identity through a piece of clothing. I thought that if I went to Japan and immersed myself in its way of life, maybe I'd finally comprehend something that had been an impenetrable mystery to me for twenty years.

But was Yohji Yamamoto the archetypal Japanese? And could I begin to under-stand the complexity of the Japanese culture—without speaking the language—just by living in Tokyo? My design experience has given me a certain ability to analyze my surroundings, but I am not an anthropologist, a historian, or a sociologist.

In Japan everything appears to be the reverse of what it is at home. The closer you get, the more elusive it becomes and the more it resists analysis and scrutiny. I soon grasped that it was probably impossible—and clearly presumptuous—for me to push things. Japan would make up its mind about what it would or would not reveal. I waited to see what surprises it held in store.

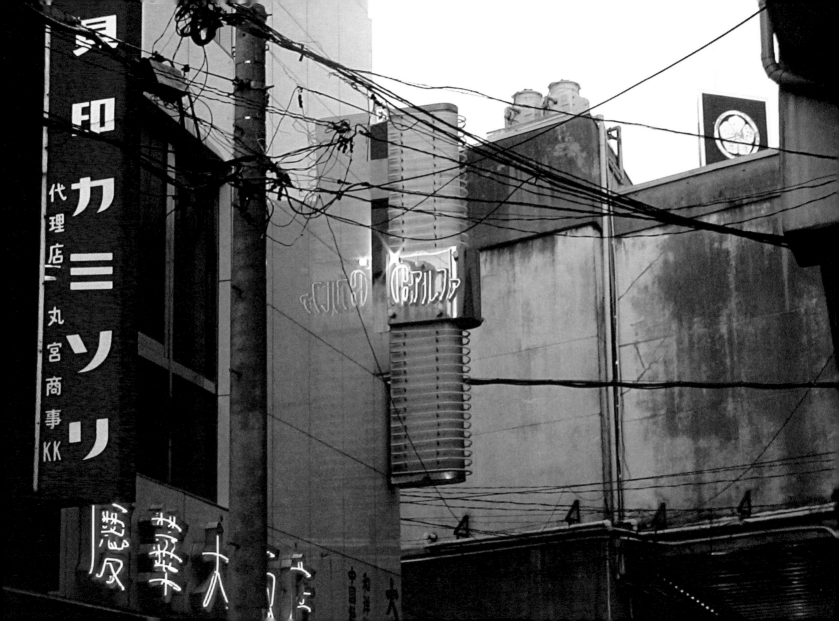

My work in clothing and couture had never given me any particular interest in the kimono. I had looked it over and concluded there was little to it beyond an uncomplicated cut. Kimonos were like other simply constructed ethnic clothes. But as soon as I arrived in Japan I found myself enthralled not only by the beauty of the garment but also by its intricacy, which was all the more surprising for my not having picked up on it the first time around.

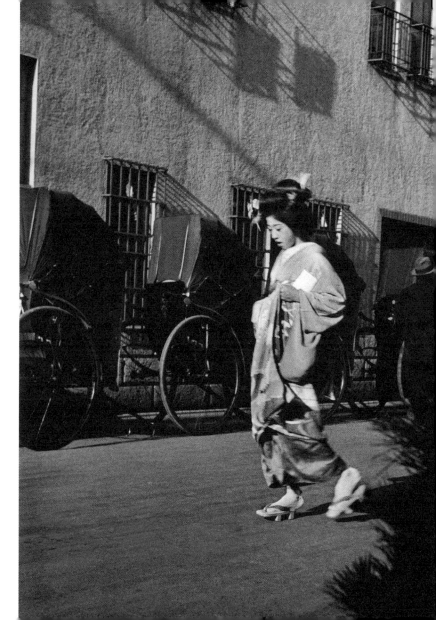

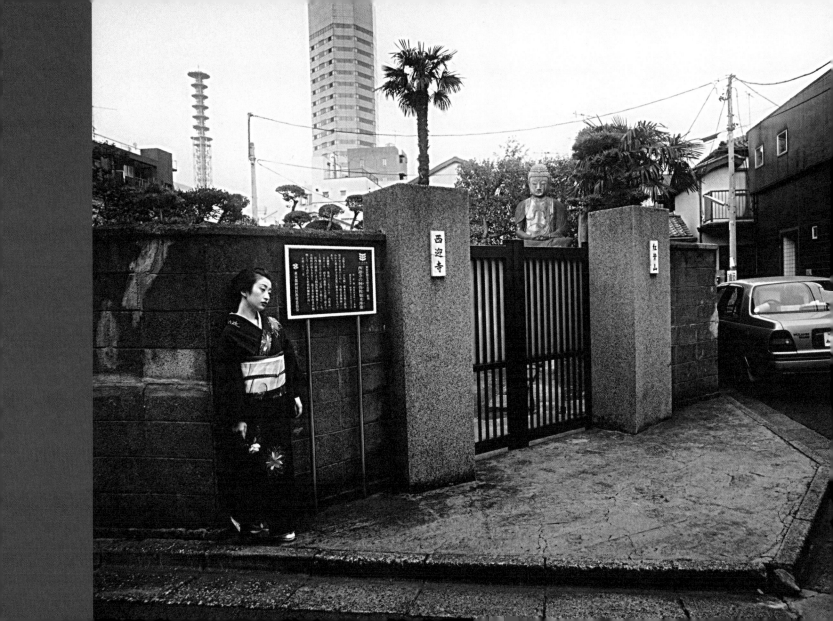

Between 1853 and 1945, Japanese clothes changed completely. The kimono, which until that time was worn by all Japanese, and whose outline had remained unaltered for 250 years, was abandoned in favor of Western-style clothes that renewed themselves every six months. Today, it is worn only on rare occasions, and then almost exclusively by women. In fact, the sight of a kimono in a motley Tokyo crowd is invariably a shock to the eye. A woman in a kimono blossoms like a flower on the metro, on the escalator of a department store, on the corner of a busy street; her bearing and elegance cast all about her into shadow.

Though seldom worn, the kimono today is far from a relic of the past. Indeed, it remains the very essence of Japanese sartorial culture. It no longer defines a certain social class as it once did; but for all that, it expresses an intense feeling of Japanese-ness. The principles that govern the wearing of kimonos have not changed since the seventeenth century, which makes the study of kimonos much easier than it would have been had they been subject to the constant shifts and changes of fashion.

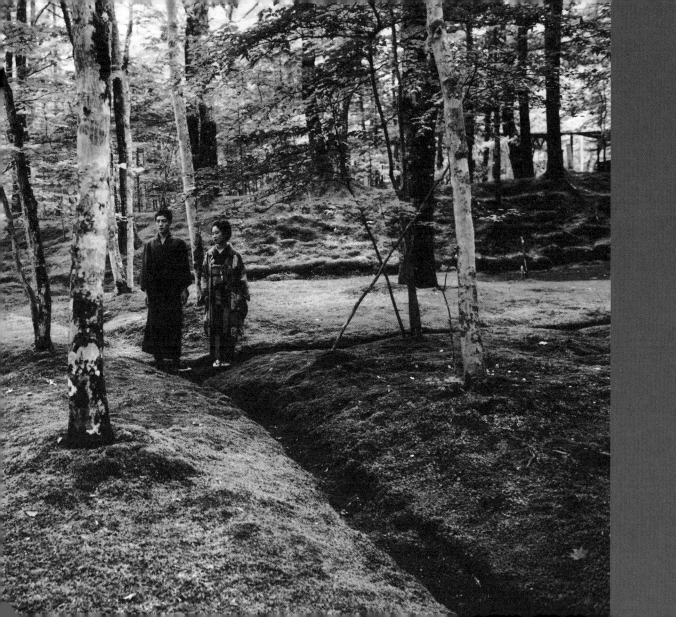

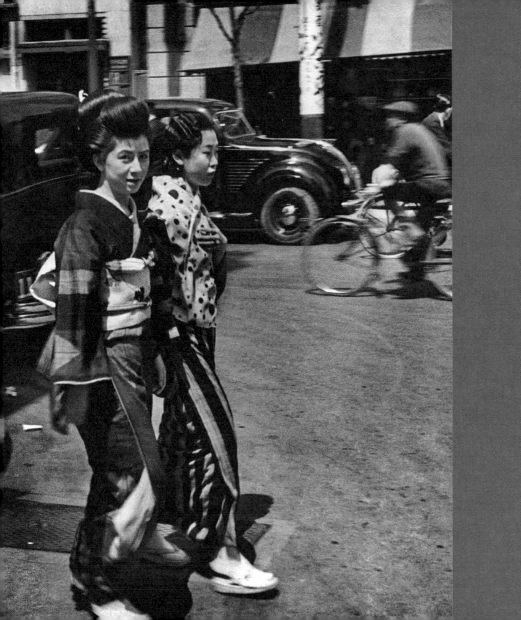

Why do we take things to pieces? What prompts children
to dismantle their toys? Why do adolescents and adults
explore the engines of motor scooters and cars? Obviously,
we want to know how such things are made—perhaps, also,
they will help us to understand how the wider world works.

dismantle

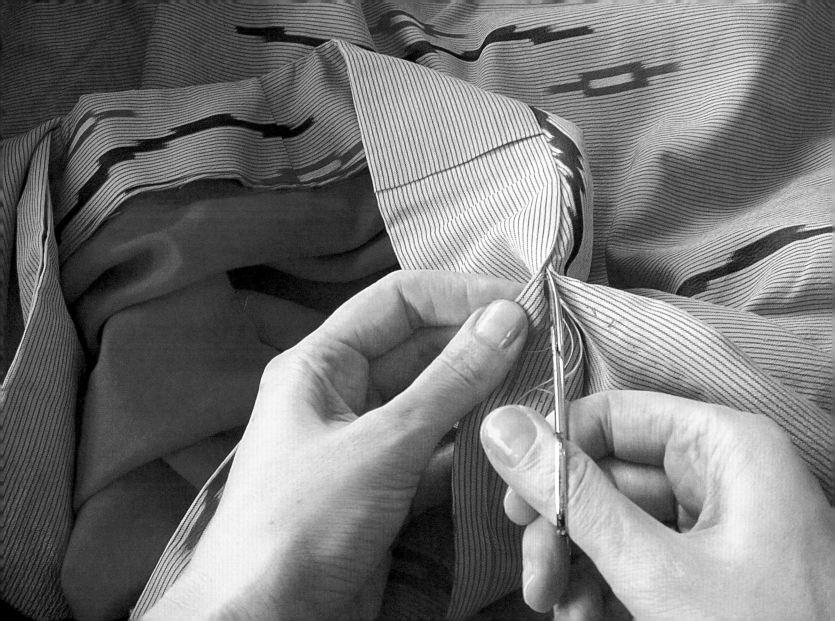

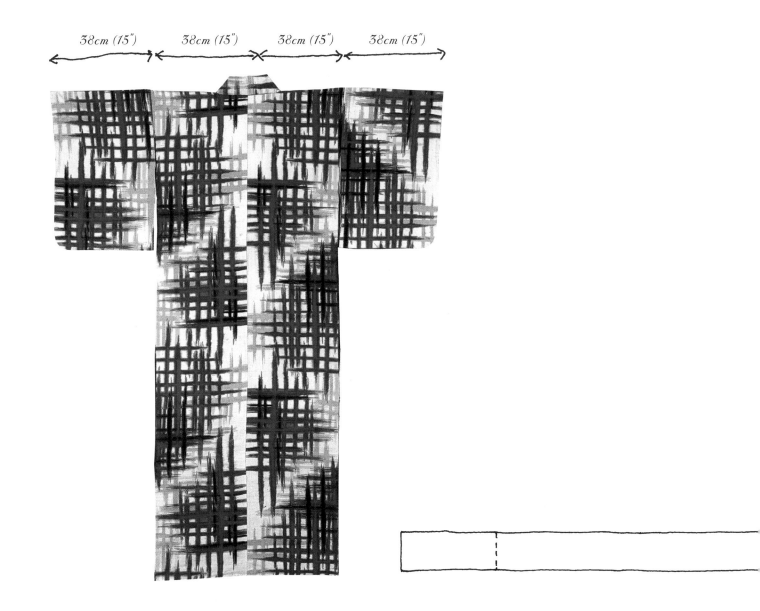

Kimonos worn today are built from a single piece of fabric of unvarying width. When you pull out the threads, you find a strip of fabric virtually intact. There is one single unchanging width for the front panel, the back panel, and the sleeves.

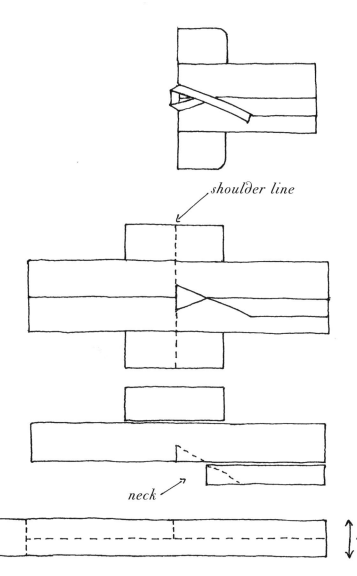

shoulder line

neck

40cm (15¾")

The fabric is altered to the absolute minimum. There is no fitted shoulder cut. The front and back panels, like the sleeves, are fashioned out of a single swatch. Thus the fabric's motif passes from front to back, and the designs are geared to take account of this fact, showing back and front. The final positions of the fixed motifs are settled at the printing or weaving stage. The sleeves of kimonos, in contrast to those of Western clothes, are cut lengthwise and placed alongside the body.

sleeve

½ back and ½ front

x 2

x 2

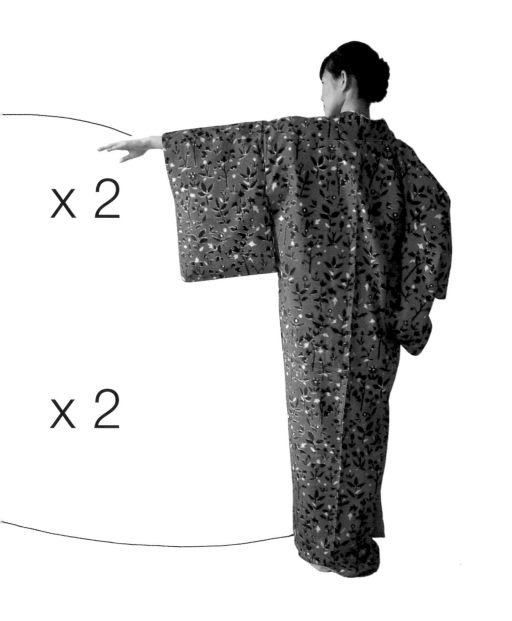

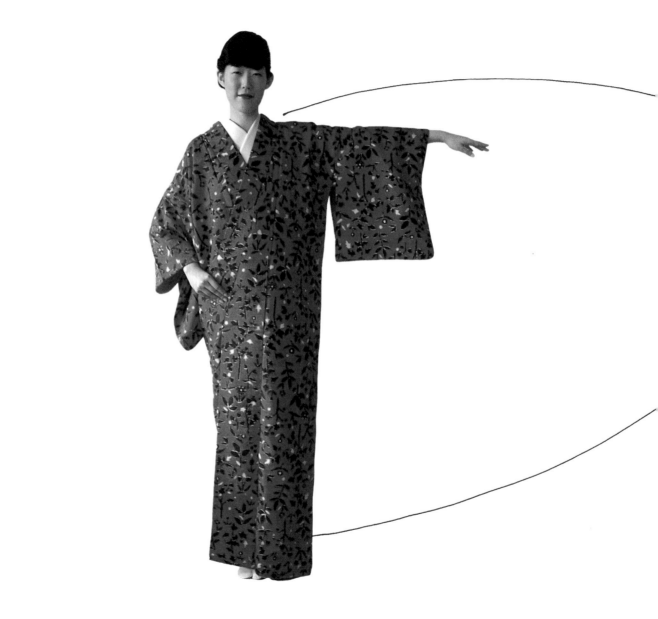

collar

x 2

edging ½ front

Only one strip is cut (lengthwise) from the fabric to make the collar and the facings; these make it possible to fold the kimono comfortably over the breast.

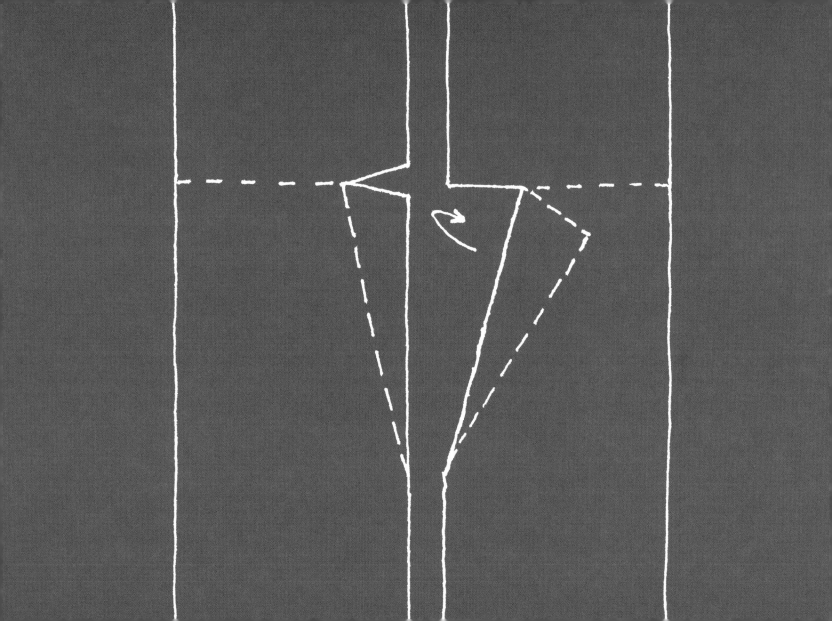

The bias of the neckline is managed with a simple fold. The fabric is slashed for the head and neck to go through, then folded again on the inside. As with origami, the shape is formed by a series of folds.

fold/unfold

The collar band is folded back
on itself several times, then sewn
on the bias along the neckline.

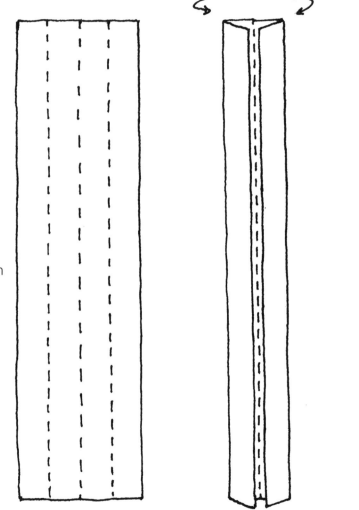

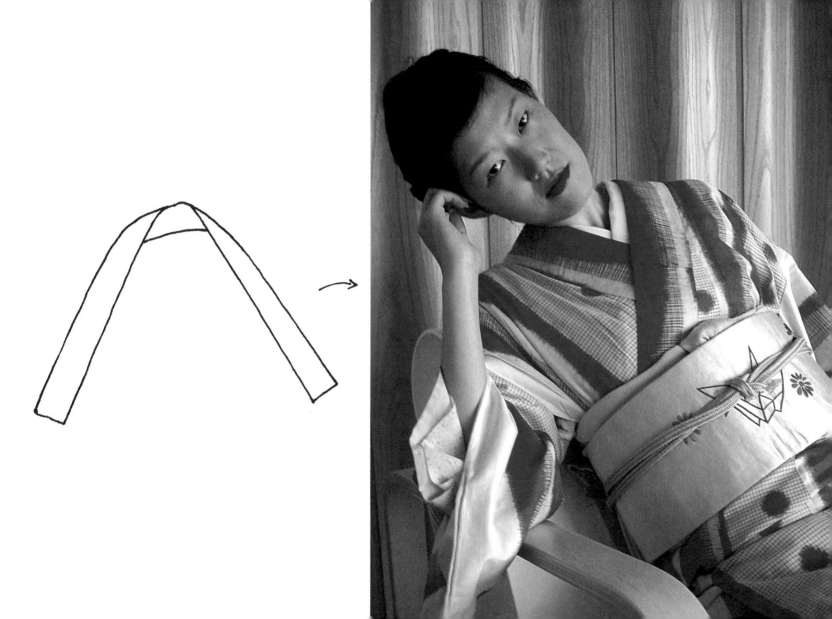

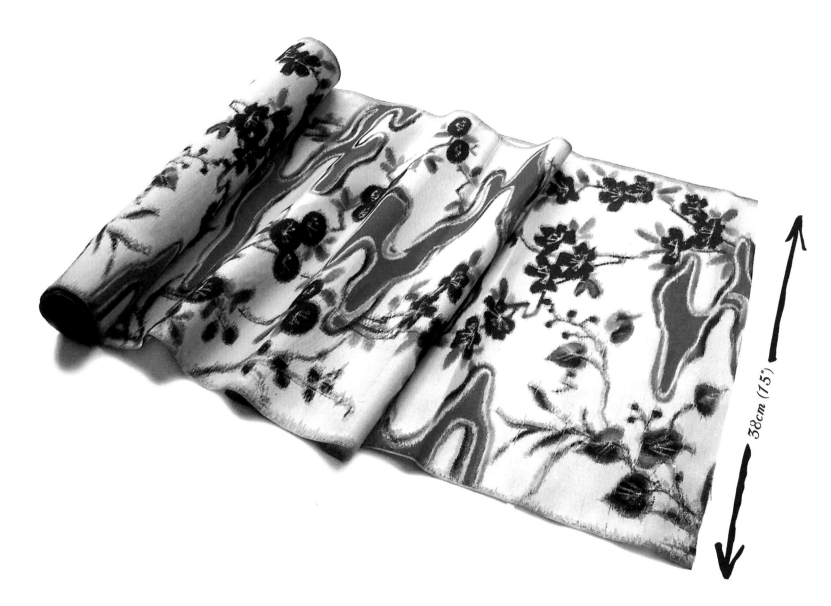

38cm (15")

The widths—38 centimeters (15 inches) for women's kimonos and 40 centimeters (15 ¾ inches) for men's—are invariable. They are determined by the weaving frame used to make the fabric. Amazingly, despite Japan's multiple weaving and printing techniques, these widths have remained uniform for at least three centuries (though very occasionally one does come across lesser widths, from a time when Japanese people were physically smaller).

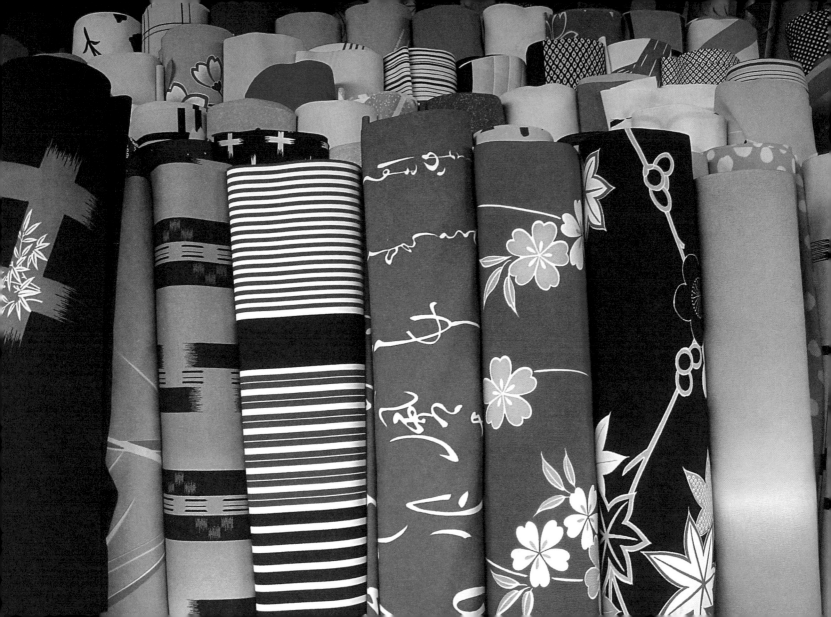

The fabric is sold in rolls called tanmono.
Each roll is of the exact length needed
to make a kimono: 13.5 meters (44.3 feet).

The cut of the kimono being also unchanged for 250 years, one might suppose that the length and width of the *tanmono* are perfectly adapted to the construction of the garment. Indeed, as early as the seventh century an imperial edict set the sizes of bolts of silk, so the Japanese have probably always been in the habit of acquiring fabrics of predetermined dimensions. Over time the format of the fabric and the cut of the kimono became mutually fixed. Every inch of the *tanmono* was used, with not a shred of material wasted. This perfect balance between fabric and cut makes the kimono a kind of ideal that needs no broadening. In the old days, kimonos would be entirely taken apart every time they were washed. Because its full width remained intact, the fabric could eventually be used for something else.

All kimonos, whether for men or for women, are built according to the same principle. Minor adaptations have been made over the years, but the basic design has remained unchanged. The body of the item has remained identical. Only the sleeves may vary.

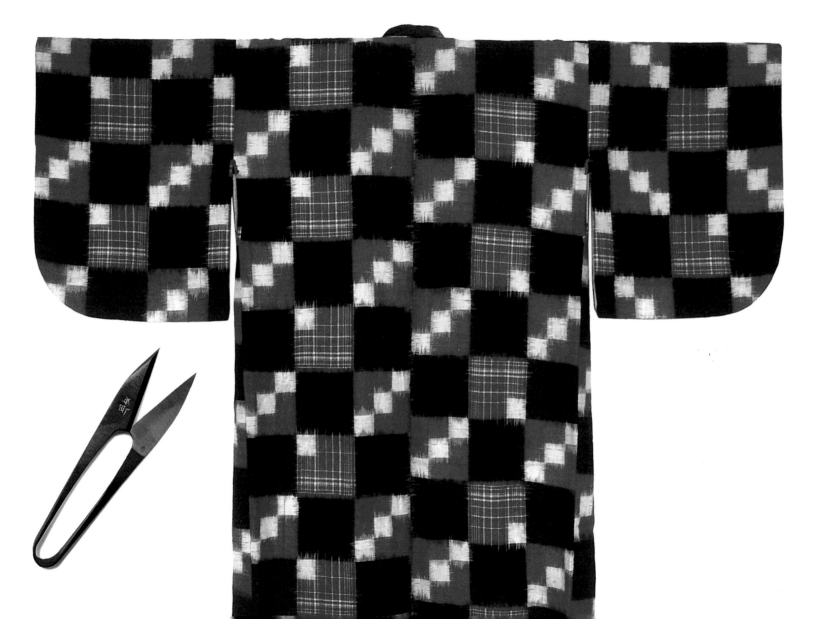

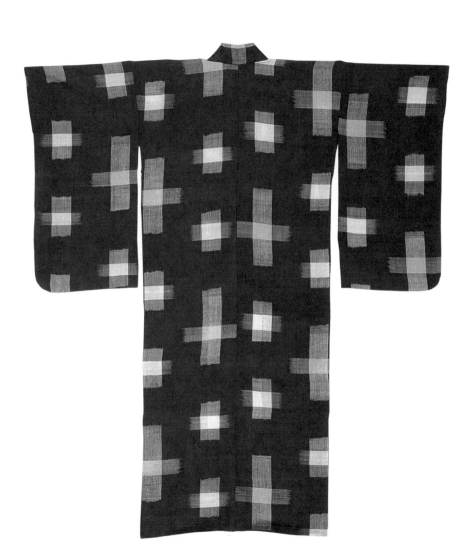

The sleeves convey important information. Thanks to the kimono's principle of construction, their length can be easily modified. These variations are in no sense a simple exercise of style but indicate very precise situations or states. For instance, the *furisode*, an extremely long-sleeved version of the kimono, is worn only by young unmarried women on formal occasions. The *kosode*, a short-sleeved kimono, is worn on less formal occasions and by married women. Thus, for women, the sleeves lengthen in proportion to the requisite degree of formality and shorten according to age. Only Enka singers have the privilege of wearing *furisode* regardless of their age and status. Kimono sleeves also have a functional dimension: they can be used as pockets.

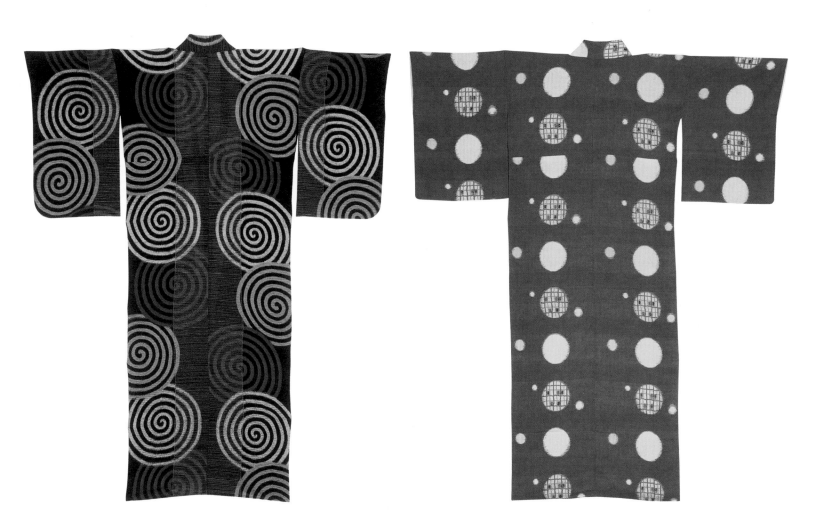

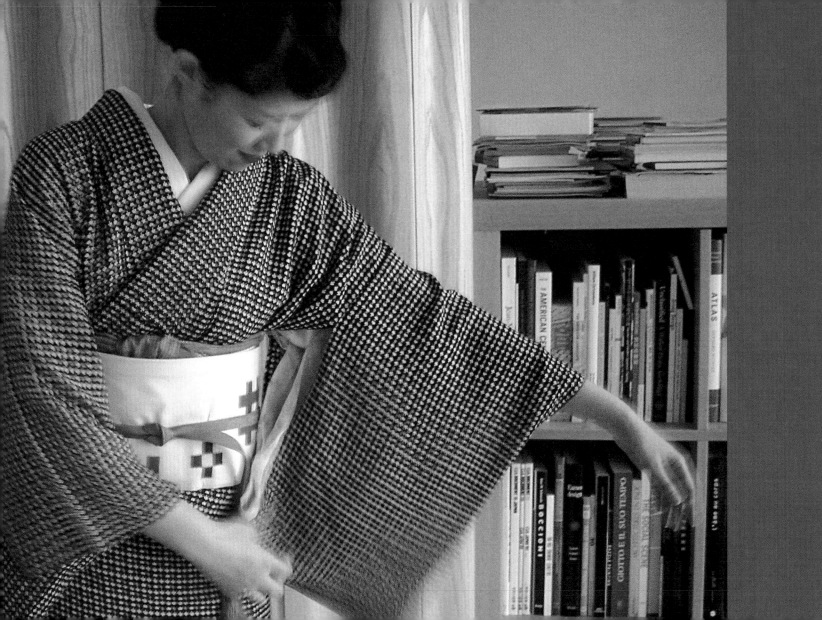

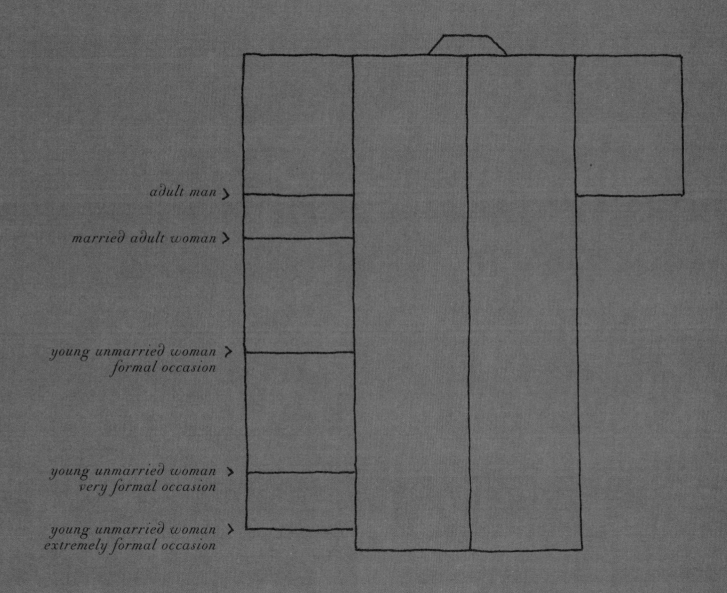

adult man >

married adult woman >

young unmarried woman >
formal occasion

young unmarried woman >
very formal occasion

young unmarried woman >
extremely formal occasion

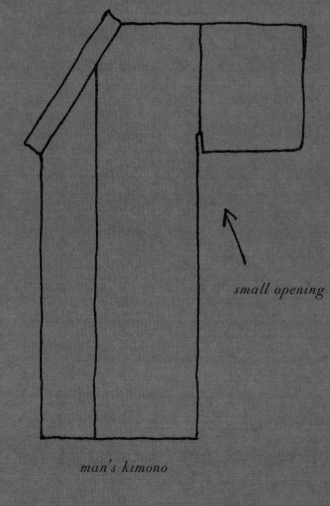

wide opening

small opening

woman's kimono

man's kimono

The sleeves of women's kimonos are freely split under the arms to admit the obi, the wide sash or belt that rides up just under the breast. This high placement of the obi gives the illusion of a silhouette with longer legs. For men, such broad openings are unnecessary, given that they wear narrow belts just above the hip.

So as not to be hampered in their movements, peasants and fishermen in the old days wore working kimonos with sleeves tapered round the wrist in a bunch of folds and seams.

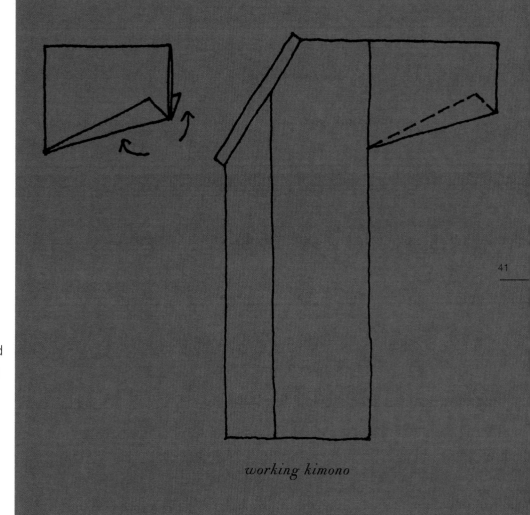

working kimono

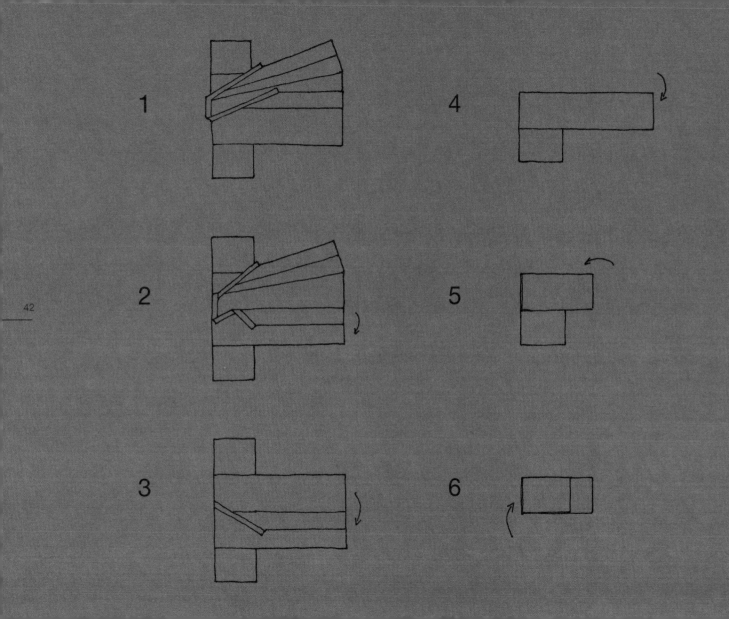

The flat construction of the kimono makes it simple to fold,
although the order of folding must be strictly observed.

fold/store

The very simplicity of the kimono, with its straight sleeves and stiff bearing empha-sized by the very flat band of the obi, gives the impression that it is never quite three-dimensional when worn. It exists, on the contrary, in a zone that is seemingly halfway between surface and volume, that is, two-and-a-half dimensional. This impression of a garment with a hint of flatness is rendered in many a Japanese print.

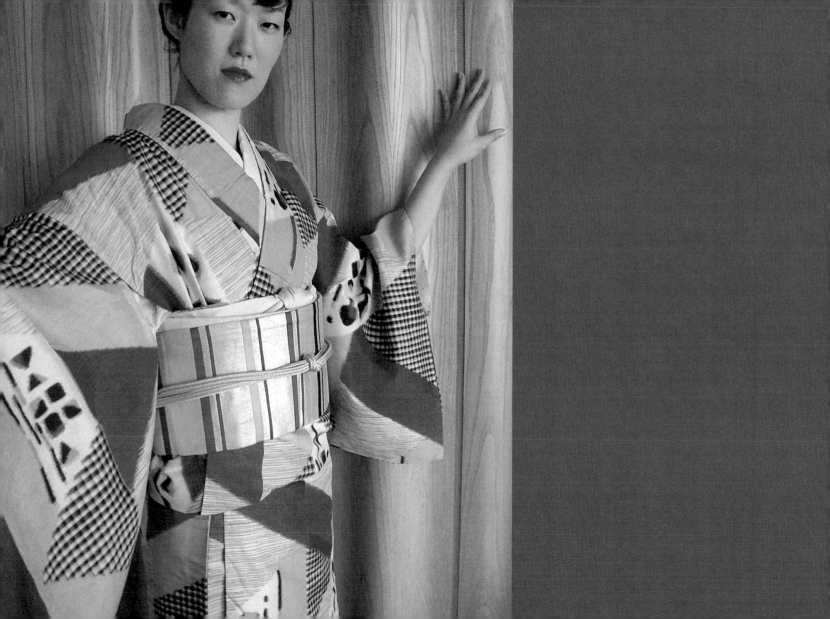

Something like 2 $^1/_2$-D

In 1843, bowing to pressure from the United States, Japan, after two hundred years of total isolation, opened its frontiers. As Nicolas Bouvier put it in his *Chronique japonaise*, "You would be hard put to find a civilized place on the planet about which we could be worse informed."* The West became fascinated with Japanese culture and its special aesthetic, and the discovery of Japanese prints radically altered Western art. Europeans, who had grown accustomed to representing the world according to the laws of perspective, were amazed that the Japanese did not appear unduly pre-occupied by these laws. As in their kimonos, they remained at a point halfway between surface and volume, as if they could only see and perceive the world within an intermediary space suspended between two dimensions. In Japanese prints, this space is known as *ukiyo-e* ("the image of the floating world").

*Nicolas Bouvier, *Chronique japonaise* (Paris: Payot, 1991), p. 86.

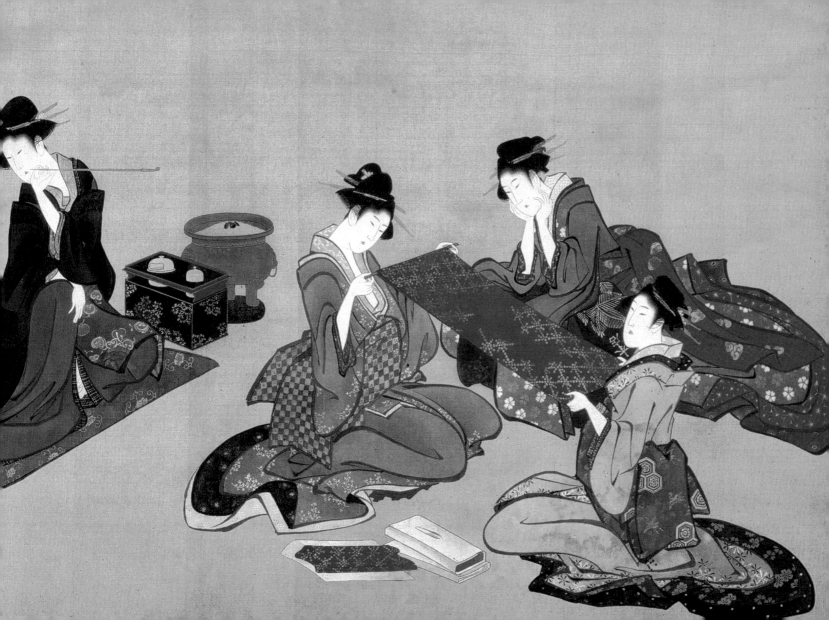

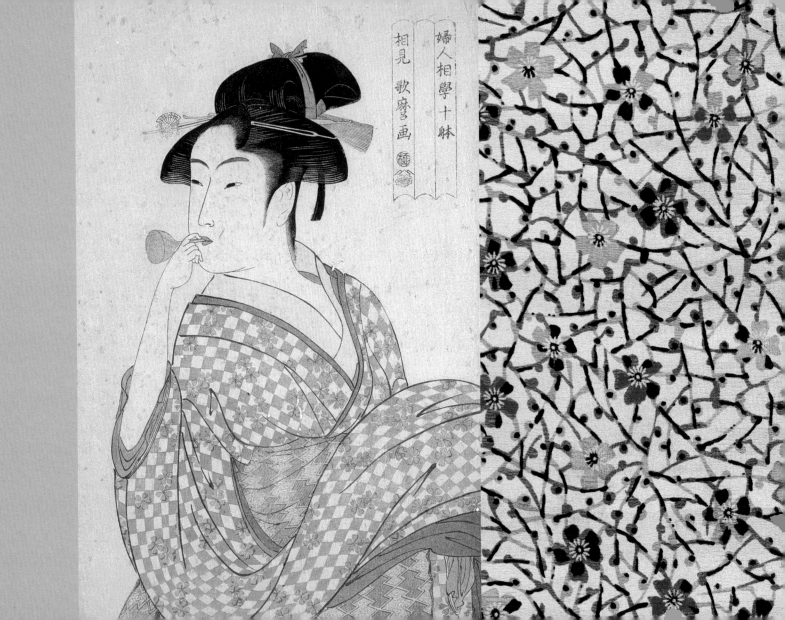

婦人相學十躰

相見　歌麿筆

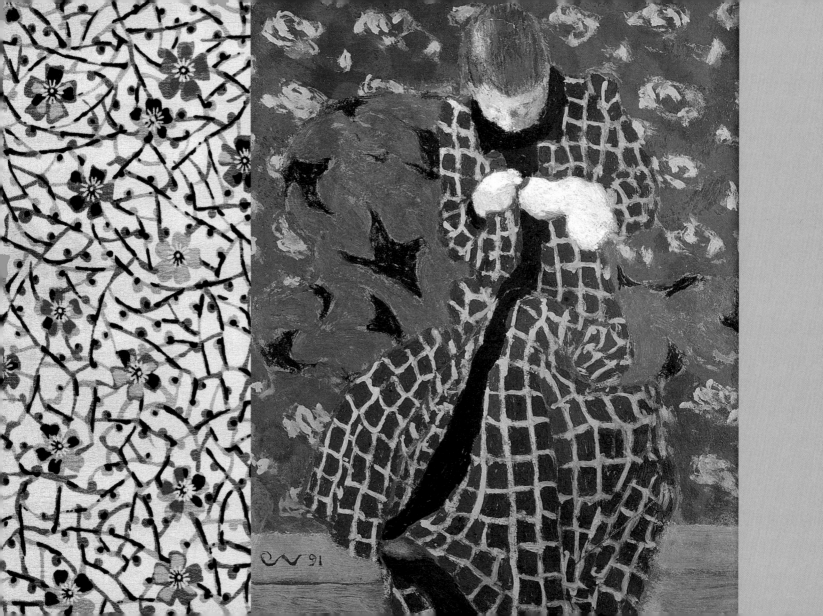

Pierre Bonnard's friends nicknamed him
"le nabi japonard" (the Japanese nabi).

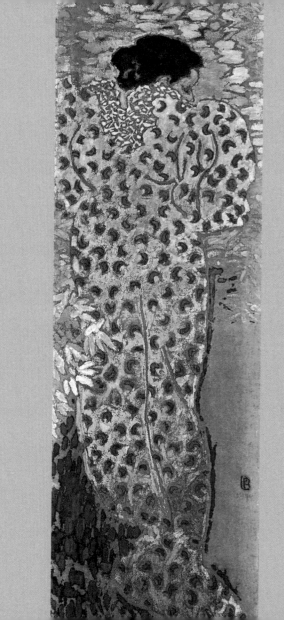

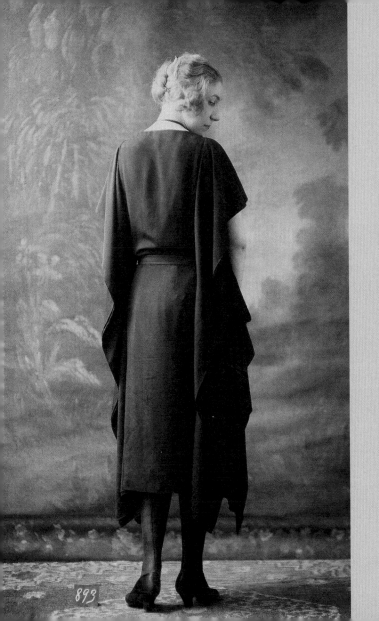

893

Many fashion designers have found inspiration in the kimono and its motifs. Mariano Fortuny, Paul Poiret, and Jeanne Jacquin all copied the simplicity and suppleness of the Japanese garment, offering the women of their time a freedom of movement that they adopted with enthusiasm. But the couturier who worked most consistently with the kimono style of flat construction was Madeleine Vionnet.

Vionnet

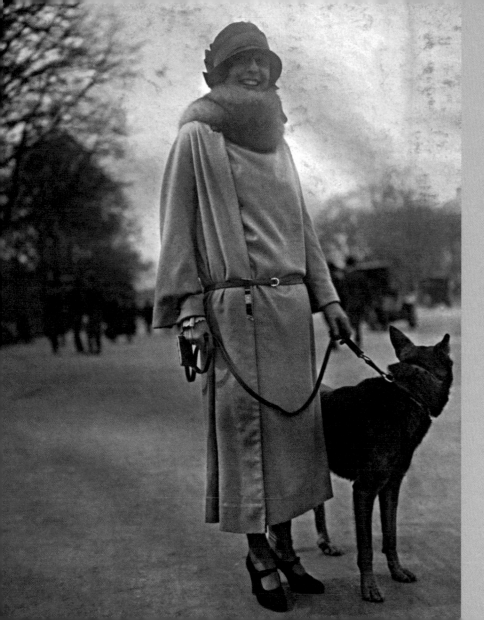

Instead of adapting the kimono to Western fashion, Vionnet focused on that aspect of its construction that made it so very different from Western clothes. Using the simplicity of the kimono's cut as a starting point, she revolutionized the entire stylistic vocabulary of her time. Her creations still look timelessly modern.

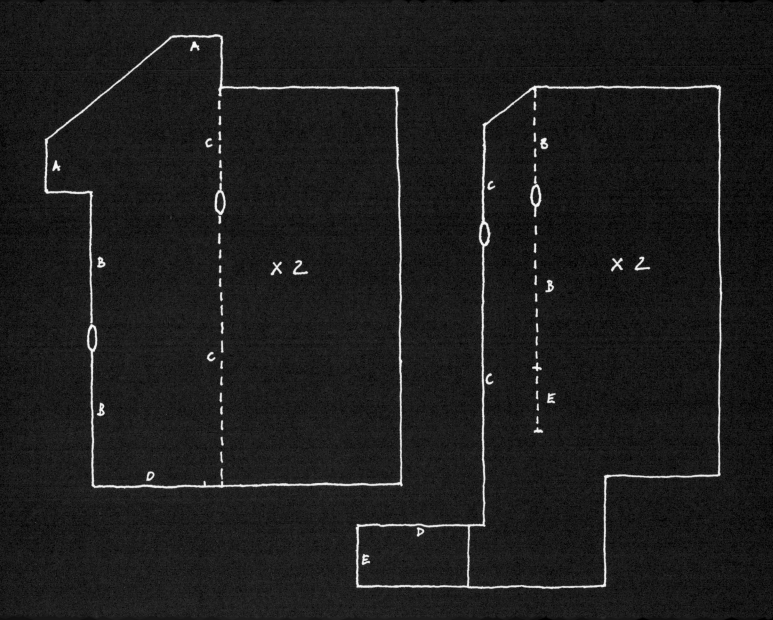

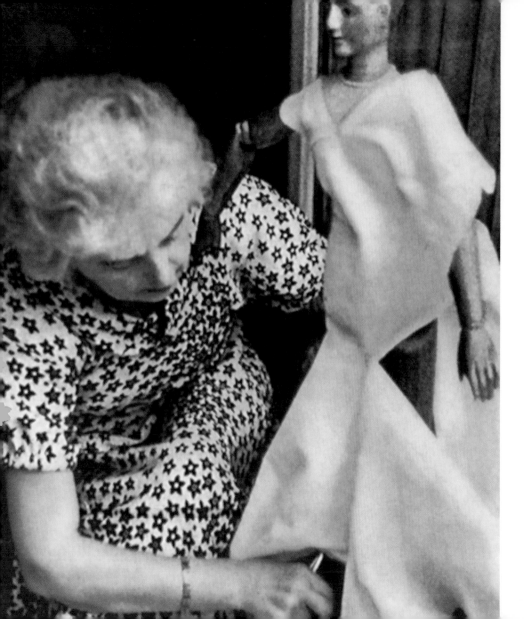

In bringing together East and West, Madeleine Vionnet combined two radically different ways of constructing clothes. Whereas the shapes and proportions of kimonos were defined by the strips of fabric with which they were made, Western garments were composed of pieces cut from a broad bolt of fabric and assembled part by part, like a puzzle.

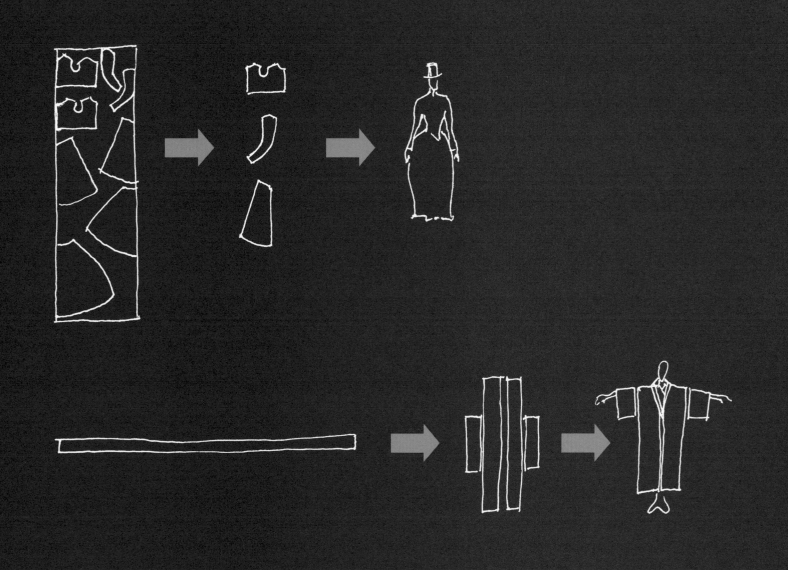

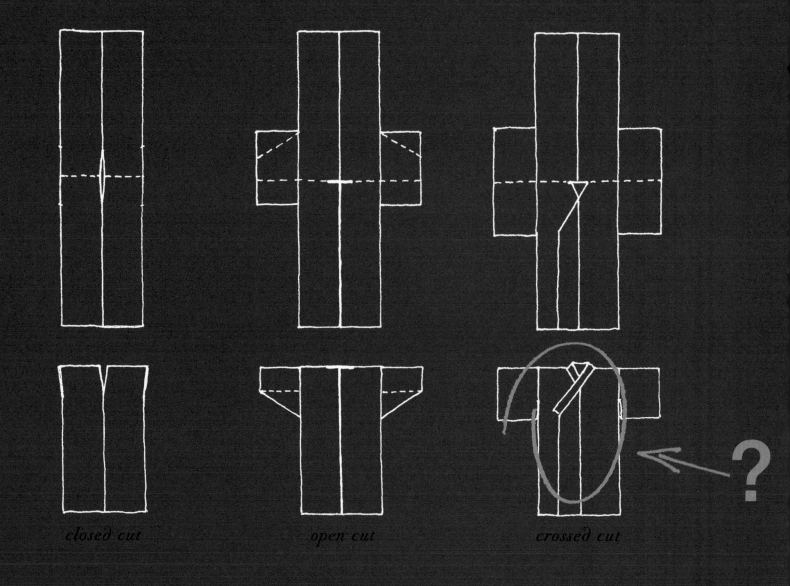

closed cut open cut crossed cut

André Leroi-Gourhan was a French anthropologist specializing in prehistory, technology, and aesthetics. In his book *Milieu et techniques,* he wrote on the subject of clothes: "It seems that the general subdivisions most frequently met with are based on the fact that the ethnic groups in question either cut, or did not cut; meaning they either used the fabrics at their disposal in bits, or else they cut pieces from them to fit the body's contours. Hence there were straight clothes and cut clothes. The first did not preclude the use of a cutting tool, nor did it necessarily result in a cylindrical appearance; it merely meant that the components, whether sewn together or no, had parallel sides."[*]

In his classification, André Leroi-Gourhan places Western clothes in the category of cut garments and kimonos in the category of straight garments, that is, those made from uncut fabrics with parallel hems. Yet he notes that within the latter (relatively rustic) category, the kimono represents a transition toward cut clothing on account of its neckline bias. So, is the kimono really a "straight" garment? Taking into account the way the pieces are put together and the way the completed garment is worn, Leroi-Gourhan remarked that the kimono was actually "a kind of hybrid," midway between the two categories. Yet it is also an object whose simplicity hides an extremely complex assembly—this is especially the case with lined kimonos—and a highly sophisticated manner of wearing.

[*]André Leroi-Gourhan, *Milieu et techniques* (Paris: Albin Michel, 1992), p. 204.

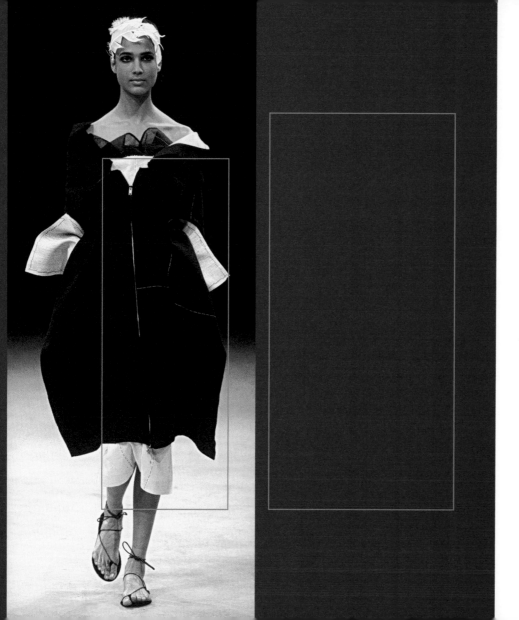

In his summer 2000 collection, Yohji Yamamoto made an amalgam of cut and straight clothes. Garments with multiple, very precise cuts, inspired by the canvases used for making patterns in the West, were associated with rectangles of fabric wrapped in the simplest way around the body, like the traditional dress of certain ethnic groups.

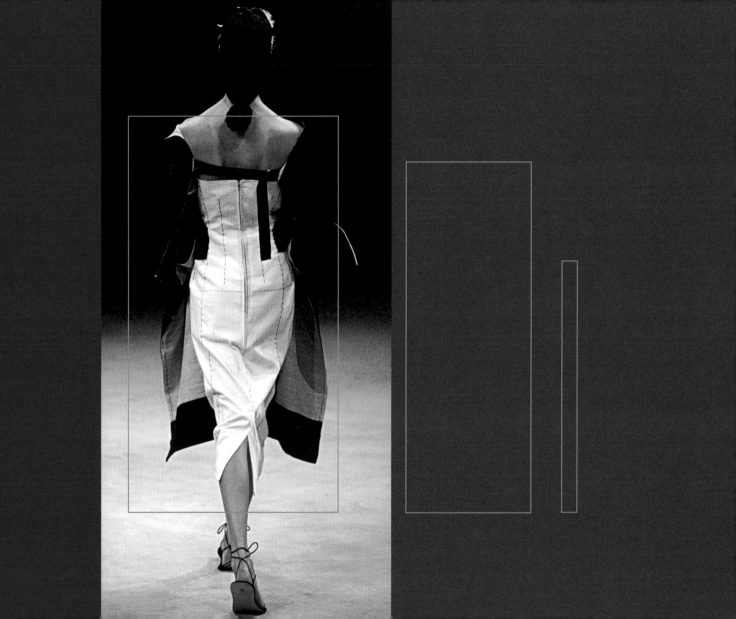

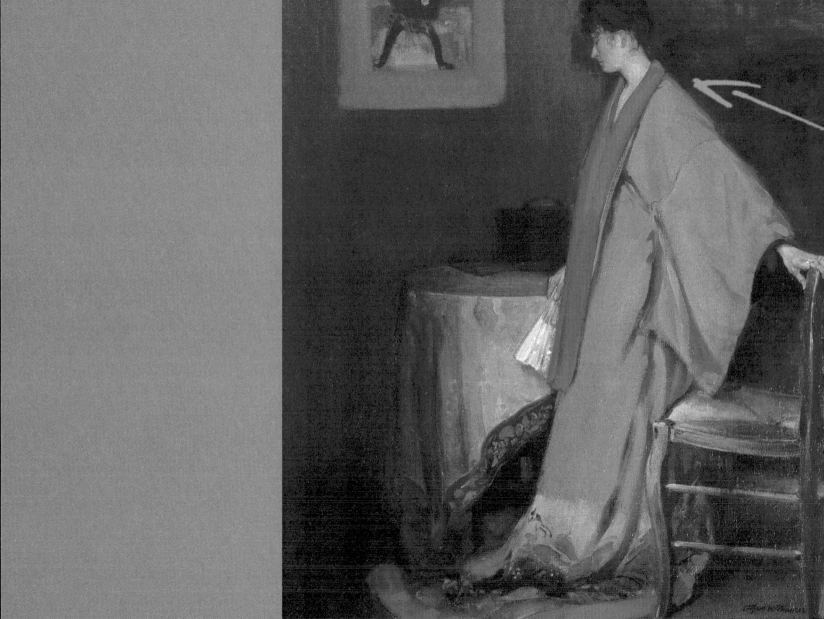

shoulder contact

In his *Milieu et techniques*, André Leroi-Gourhan suggests classifying clothes not so much in terms of the parts of the body they cover as by the function of their points of contact with the anatomy. "In arranging the components of a garment, we normally begin with the body parts that are to be covered: head, arms, legs, trunk, etc. This classification is entirely theoretical and I felt I ought to modify it by taking as my dividing points not the regions that are covered, but the points where the fabric rests against the body. Actually the protection of the parts of the body is a variable: one may, for instance, lengthen a blouse till it reaches to the ankles, or shorten it right up to the hips: the *fact* of the blouse, with the technical constraints it implies, is the only important thing. If one starts with the fastening points, things are simpler: the places where clothes can be fastened or hung on the human body are not very numerous. They are the head, the neck, the shoulders, the breasts (in the case of women), the hips, the elbows, the knees, the hands, and the feet. So one actually needs only to categorize the various parts of a garment according to the places where they are fastened, to arrive at a workmanlike system for dividing them up." *

* André Leroi-Gourhan, *Milieu et techniques*, op. cit., p. 203.

かぶります
kaburimasu
wear a hat

This classification exists in the Japanese language. Thus, the wearing of something that rests on the shoulders or the lower part of the body and the wearing of an accessory or a hat have different words to describe them. The word *kimono* is itself derived from the verb *kimasu*, meaning "to wear on the shoulders."

はきます
hakimasu
wear on the hips

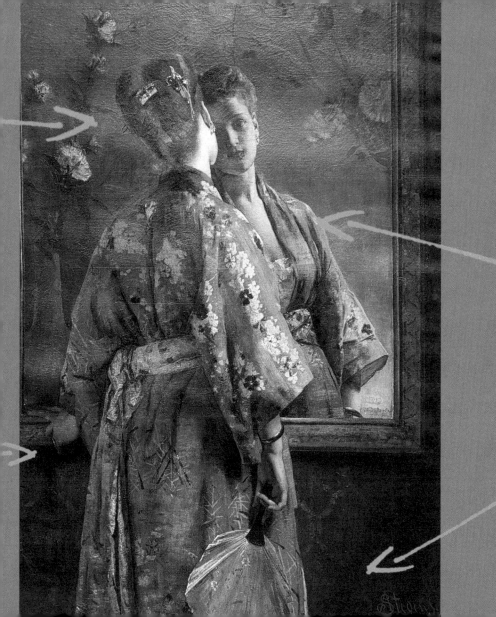

きます
kimasu
wear on the shoulders

します
shimasu
wear an accessory

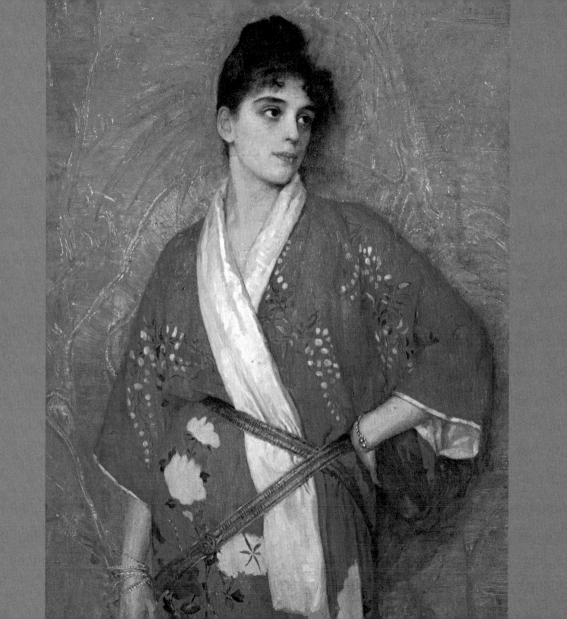

André Leroi-Gourhan spent two years in Japan, between 1937 and 1939, researching its materials and culture, but did he know the clothing classifications that exist in the Japanese language?

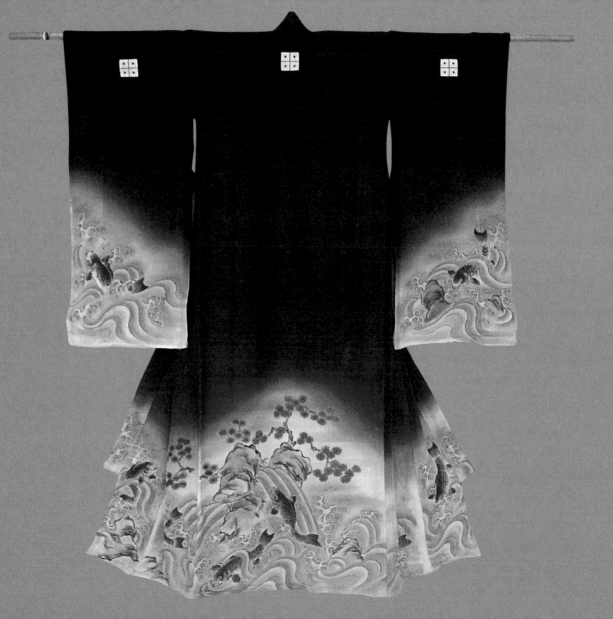

While the simple shape of the kimono has remained unaltered since the seventeenth century, the garment itself is constantly being revised with new materials. Textile makers have always known how to use the kimono as a splendid vehicle for their creations, and the fabrics used for kimonos are infinitely diverse in terms of materials, weaving or printing techniques, designs, and colors. Different regions have evolved specific techniques or styles, reflecting an extremely complex orthography easily recognizable among Japanese people. The Japanese pay enormous attention to detail, and because of this can go into ecstasy just as much over an extremely discreet kimono as they might a richly decorated one. Westerners are sometimes amazed to witness not only the enthusiasm of the Japanese for a motif, not grasping its subtlety, but also the Japanese refusal to be shocked in any way by its extravagant price. The Japanese place a very high value on the craftsmanship of their country; in their eyes the prohibitive cost of Japanese textiles is a just reward for virtuosity, technical complexity, and adherence to tradition.

diversity

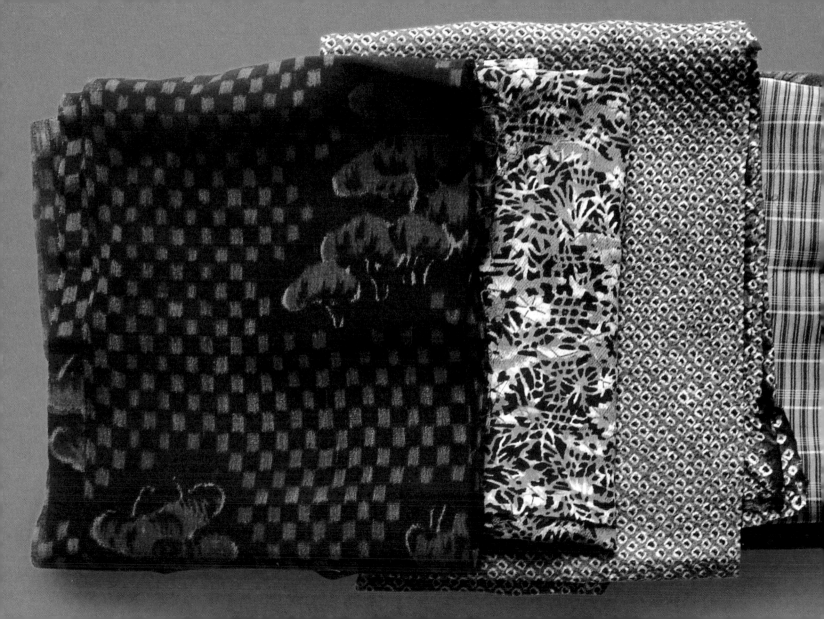

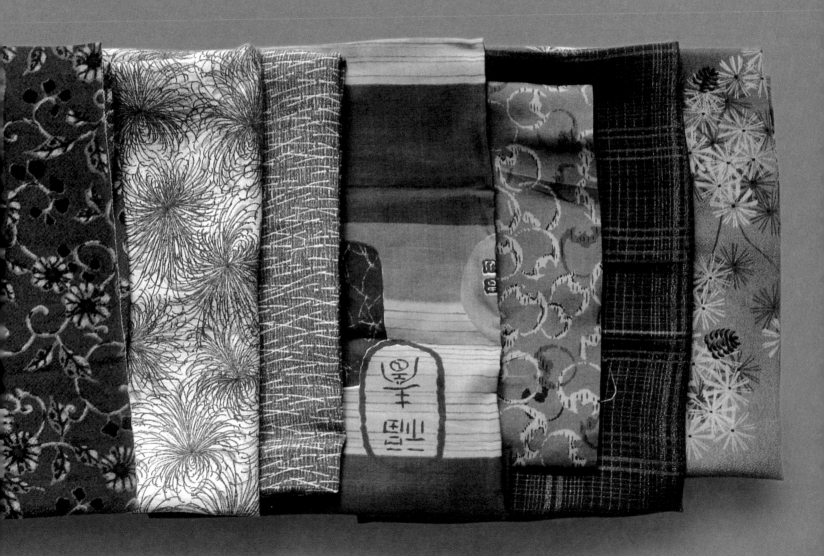

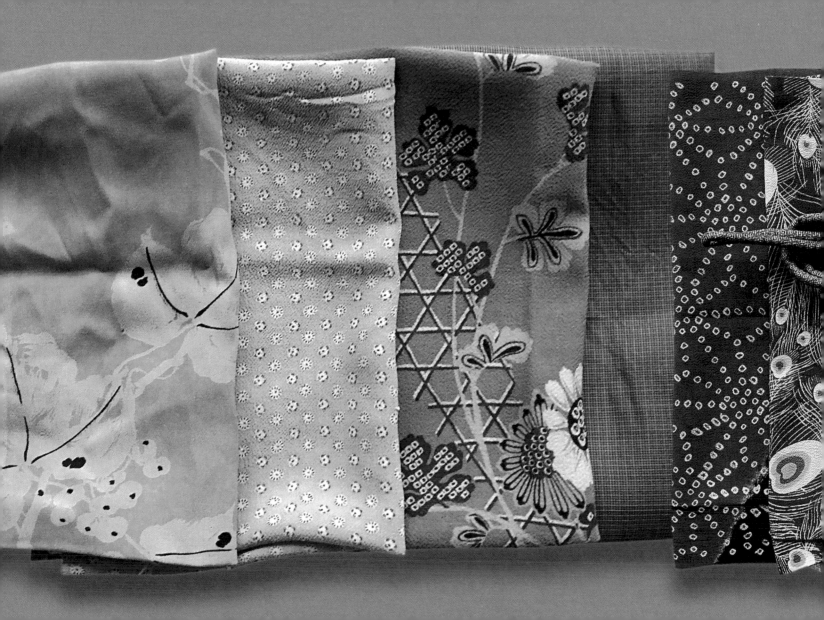

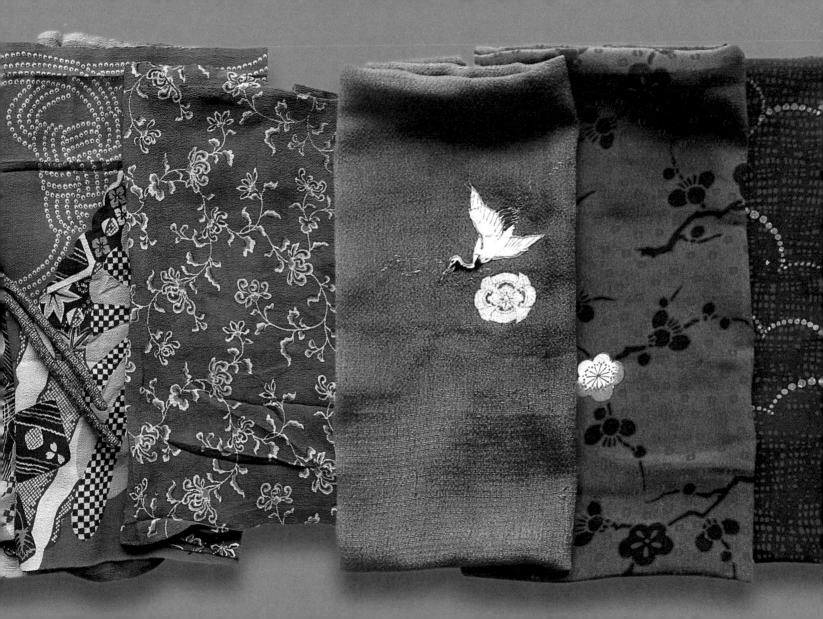

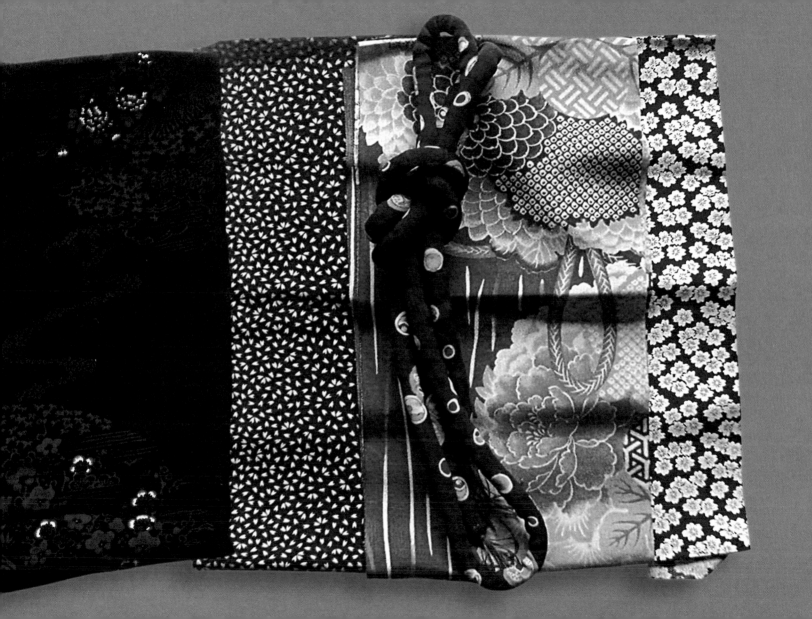

Even though they are seldom worn these days, kimonos are sold everywhere, from fashionable department stores to flea markets by way of made-to-order shops. Yet despite their quantity, you almost never see the same motif repeated. The fabric being manufactured by *tanmono*, the design can be changed with each new roll. Craftsmen take advantage of this flexibility to give free rein to their creativity. Even today the kimono has yet to be mass-produced. It may be added that since a new kimono represents a considerable financial outlay, female clients expect and insist upon a certain exclusivity.

Such richness of fabric is symptomatic of a diversity that is common to many other aspects of Japanese culture. The American anthropologist Ruth Benedict writes in *The Chrysanthemum and the Sword* that "it is difficult to find anywhere in the history of the world any other such successfully planned importation of civilization by a sovereign nation."* In other words, the Japanese take from others that which they deem worthy of interest, without renouncing their own identity. In the past Japan borrowed much from the rich culture of its neighbor China, but it always managed to find its own way in the world. It would seem today that other foreign cultures—especially the American—continue to impose themselves on Japanese culture without undermining it. The cohabitation of occidental and oriental cultures gives a sense of diversity and openness to the rest of the world, which has largely ceased to exist in most Western societies.

*Ruth Benedict, *The Chrysanthemum and the Sword* [1946] (Boston: Houghton Mifflin, 2005), p. 58.

During the Heian period (794–1185), the women of the Japanese court wore multiple kimonos, one on top of the other. This fashion was known as *juni-hitoe*, meaning "twelve thicknesses," but the number of kimonos could go as high as twenty-five, making movement virtually impossible. The use of colors was rigidly codified, some being the privilege of an exclusive imperial circle. Within this framework, the association of colors became an extremely sophisticated art that despite the tight constraints subtly reflected seasons, virtues, or sentiments, in addition to a taste or talent for demonstrating one's personal sensitivity. This art was known as *irome no kasane*. All the literature of the time, and especially the poetry of Sei Shonagon, reflects a careful attention to chromatic blends and their significance. This sensibility to colors, which remains very much alive today, is the legacy of a very rich period in Japan's history.

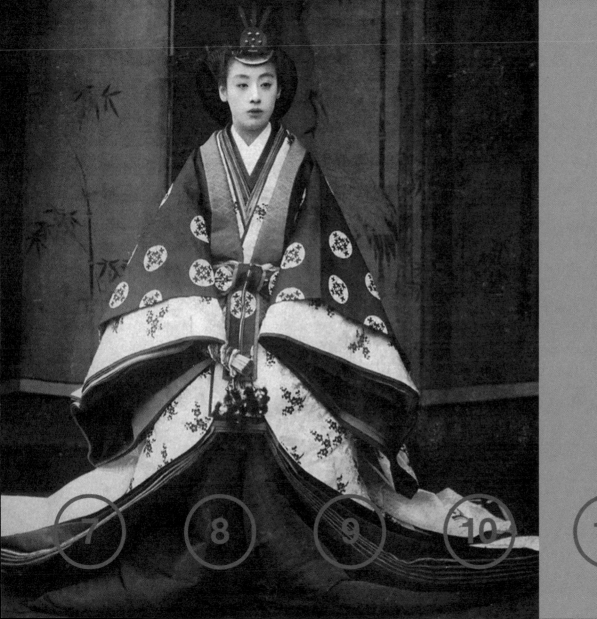

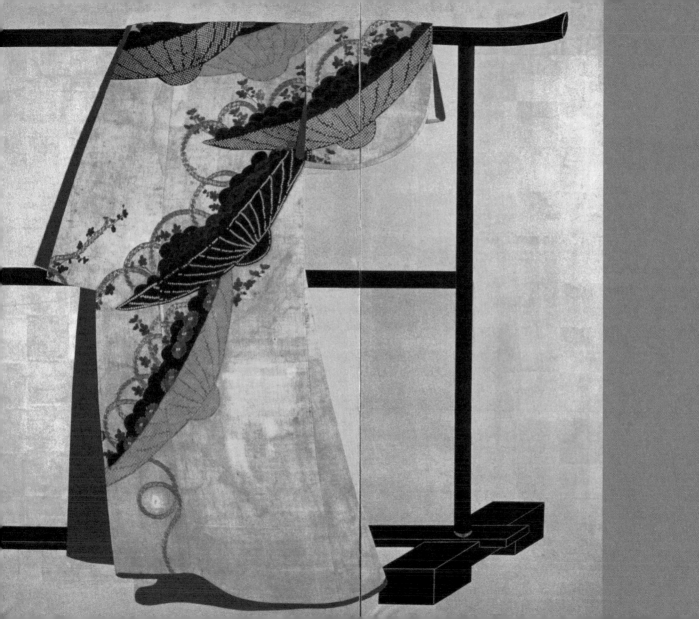

Among the aristocracy, the heavy layered kimonos of the Heian period were progressively abandoned in favor of the *kosode*, a simple kimono originally worn next to the skin under the twelve or more others. As so often in the history of clothes, the undergarment became the over garment. Originally white, the *kosode*, thanks to its refined shape, became the ideal support for the varied, flamboyant motifs of the Edo period (1603–1867). The kimono appeared at this time in the form that has remained unaltered to this day. The obi also became a crucial element of the costume; beginning as a narrow belt, it gradually broadened over the decades to a point where it cut the outline of the kimono in half. The designs of kimonos, which in the early seventeenth century sprawled grandly from shoulder to ankle, had to be organized differently to accommodate the growing breadth of the obi; either they were concentrated on the lower parts, or else they became smaller and more repetitive. At this time the kimono turned into a kind of background against which the obi stood out. Also during the Edo period, the sleeves of the kimono, which had originally been entirely sewn to the body of the garment, were freed lower down to let in the obi.

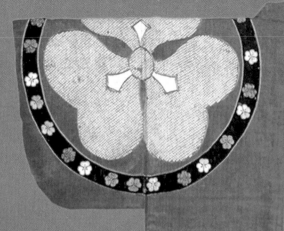
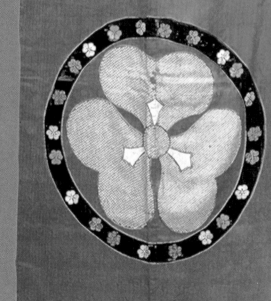

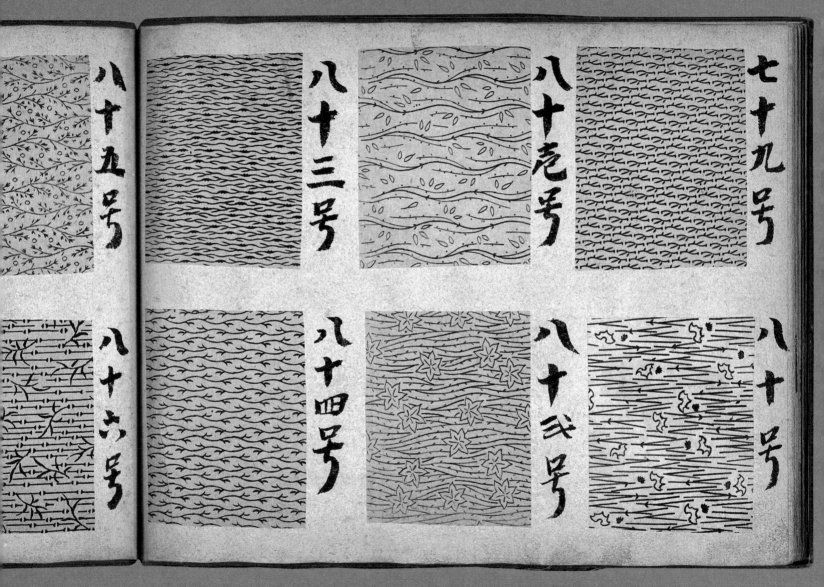

八十五号

八十三号

八十九号

七十九号

八十六号

八十四号

八十弍号

八十号

In the early eighteenth century, laws were established that made the wearing of flamboyant kimonos the exclusive privilege of the aristocracy. In reaction, a vogue emerged for tiny, subtle patterns in muted tones. Kimonos made with these fabrics were all the rage, especially when they were lined with the brightest colors and the most extravagant designs. This style, known as *iki*, was a subtle way of getting around the new laws and an absolute benchmark of chic at the time. It also symbolized the Japanese taste for things discreet and even concealed. Today, these motifs are still known as *Edo komon*.

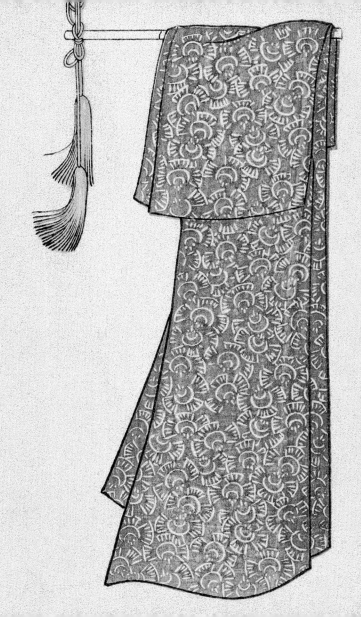

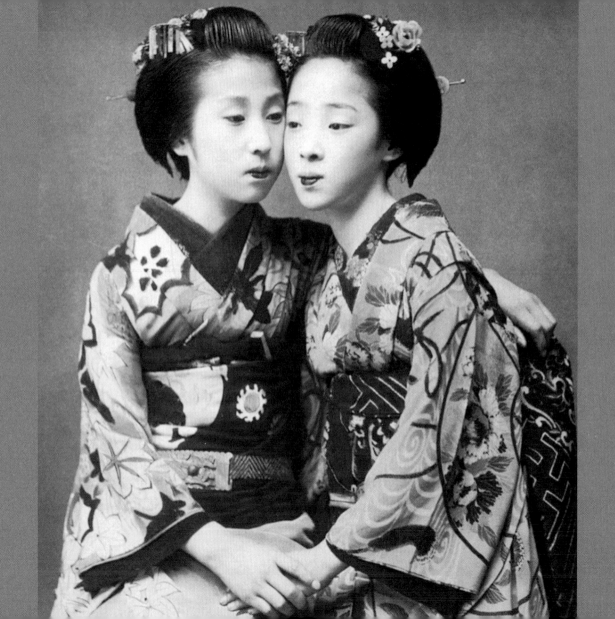

During the Edo period, kimonos and obis became
inseparable elements. But the choice of textiles and their
associations continued to obey very precise regulations
with respect to the season, the age of the wearer, her social
status, and the situation in which the kimono was worn.
Kimonos and obis had to follow these rules to the letter,
while at the same time express the taste and sensitivity
of their owner. This subtle, precise science of blends and
mixtures still survives today, creating compositions of
design and color that are highly unusual to the European
eye. And in Tokyo, where, more than in any other capital,
the inhabitants thirst for industrial products from all over
the world; where the mix of clothes is the most creative on
the planet; where tradition goes hand in hand with the
most aggressive modernity, the art of the mixture seems
inherent to the culture.

mixtures

In the history of costume, it is often difficult to find very old sources of study that concern the more modest sectors of the population. This is as true of Japan as it is of other countries. All the same, wearing kimonos in layers seems to have been a long-standing tradition shared by rich and poor. The fabrics were not as opulent, but the same associations of motifs were present. Kimonos worn outside the imperial court probably didn't produce the same subtle shades of meaning as those inside did, but they certainly contributed to the development of the acute visual sensitivity that is common to all Japanese. A whole series of motifs became "classics" as time went by. The stylization of flowers, foliage, animals, waves, and clouds became a uniquely Japanese graphic specialty, a kind of ode to nature and the seasons blended with stripes and squares.

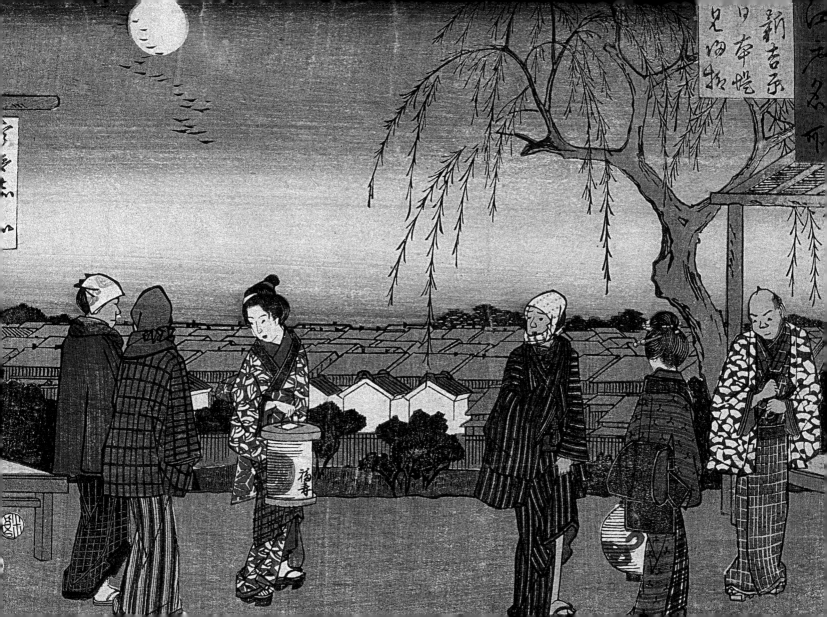

The feast days of Japan offer a constant celebration of nature and her metamorphoses. As Nicolas Bouvier puts it: "After the cherry blossom festival come the festivals of hollyhocks, irises, and azaleas; then it is time for the feast of Tanabata, which celebrates the conjunction of two stars, the Waggoner and Vega. October brings the festival of the maples, whose reddening leaves give joy to the monks in their temples. The whole Japanese year turns around constellations, flowers, leaves, the green shoots, and ripening ears of the rice plant." [*]
Every year, the climate coils back on itself, and the kimonos in their own way reflect its returning cycles. A kimono's motif follows the rhythms of the seasons. For centuries no one would dream of wearing a kimono out of season or context. One would never wear a flowering cherry at any other season than spring, for example, and it would be in even worse taste to wear it in late spring, after the blossoms had fallen. Understandably, with constraints such as these, the wearing of a kimono is not something to be taken lightly. Even today the most conservative Japanese consider the rules to be set in stone and strongly disapprove of the freedom with which they are sometimes interpreted by young women of the avant-garde. But perhaps convention needs to be given the occasional nudge, if the kimono is to remain a living art.

seasons

[*] Nicolas Bouvier, *Chronique japonaise*, op. cit., p. 37.

spring

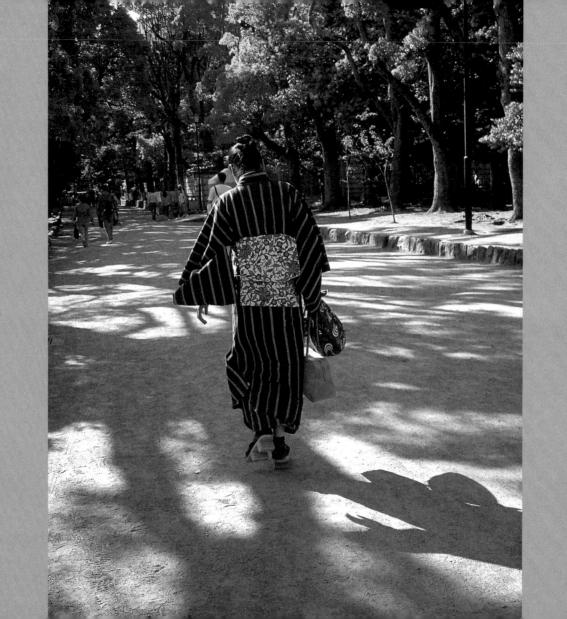

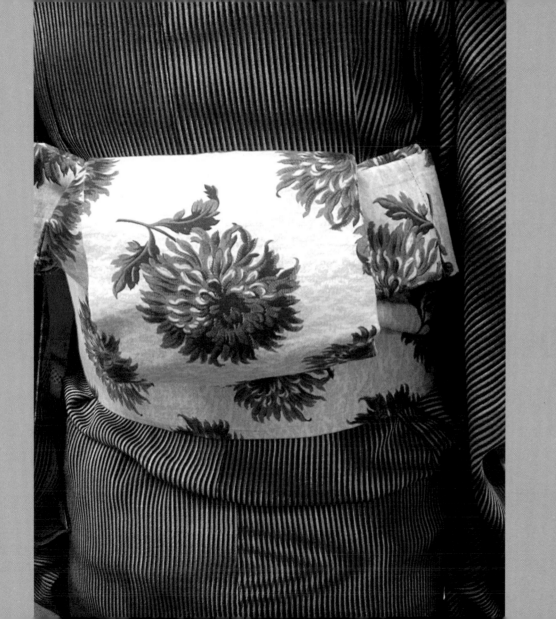

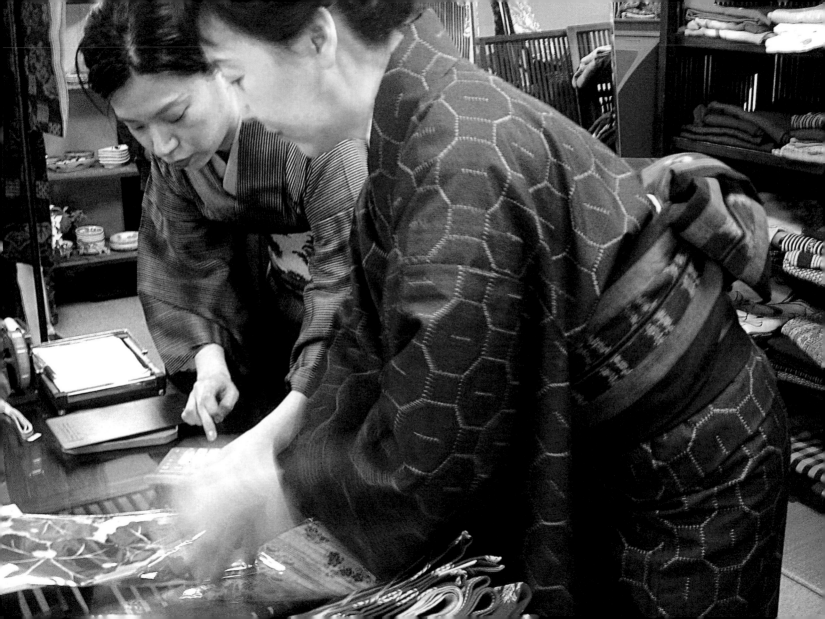

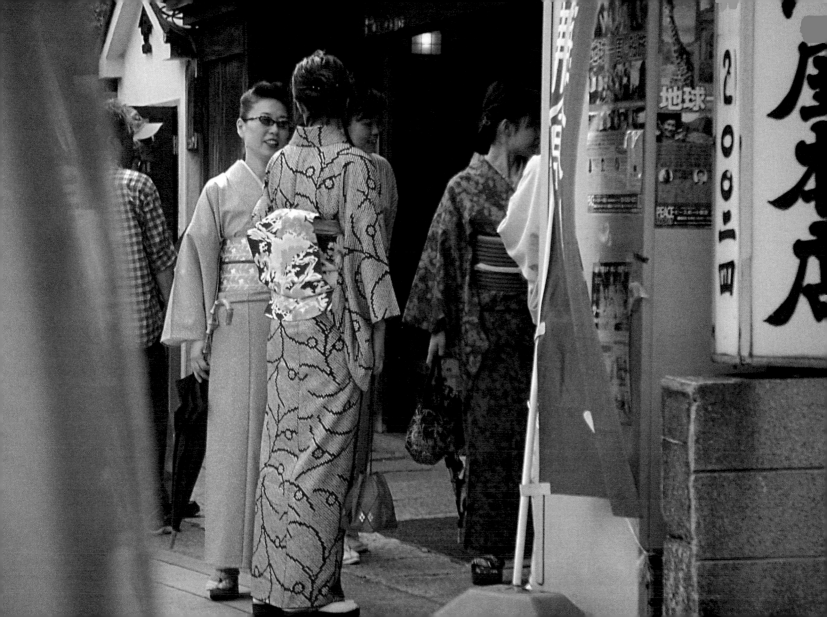

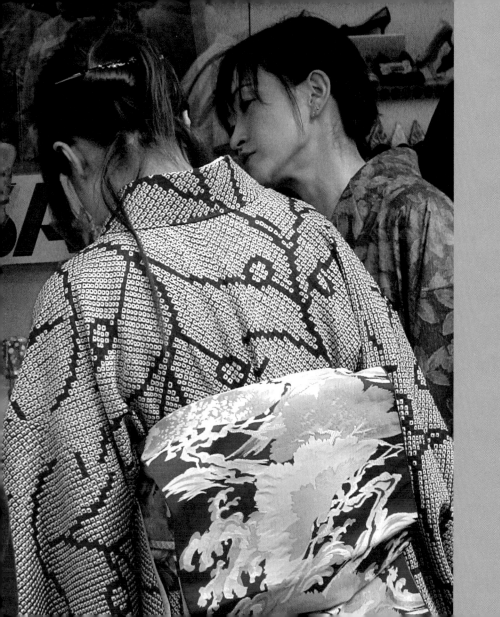

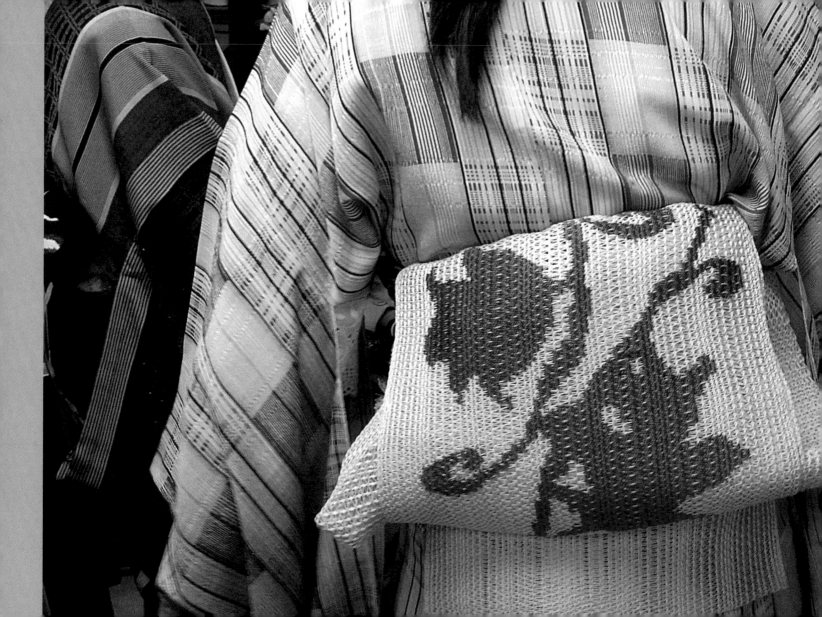

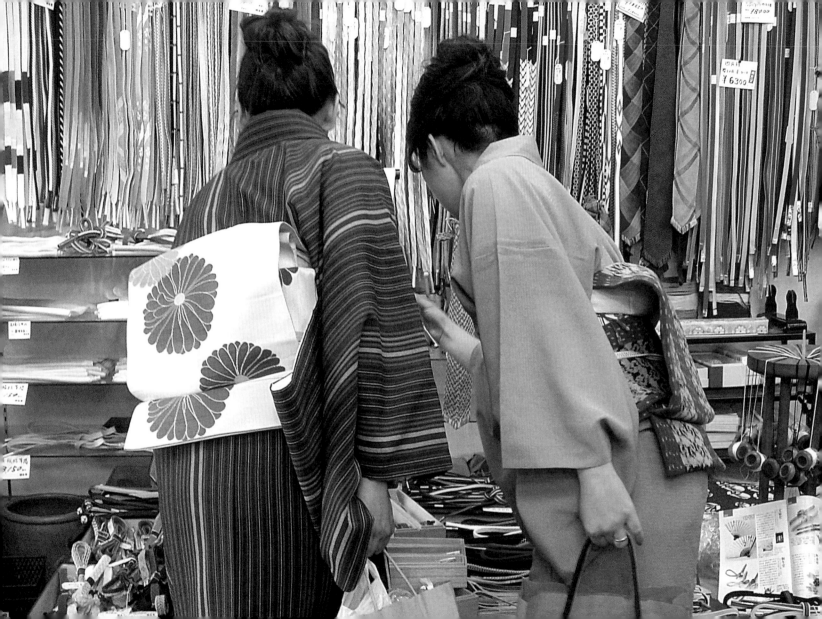

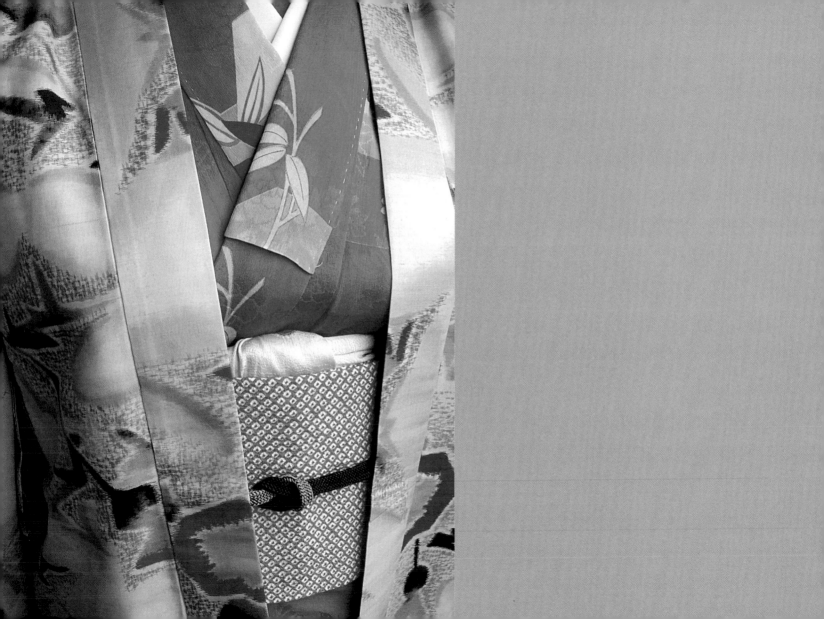

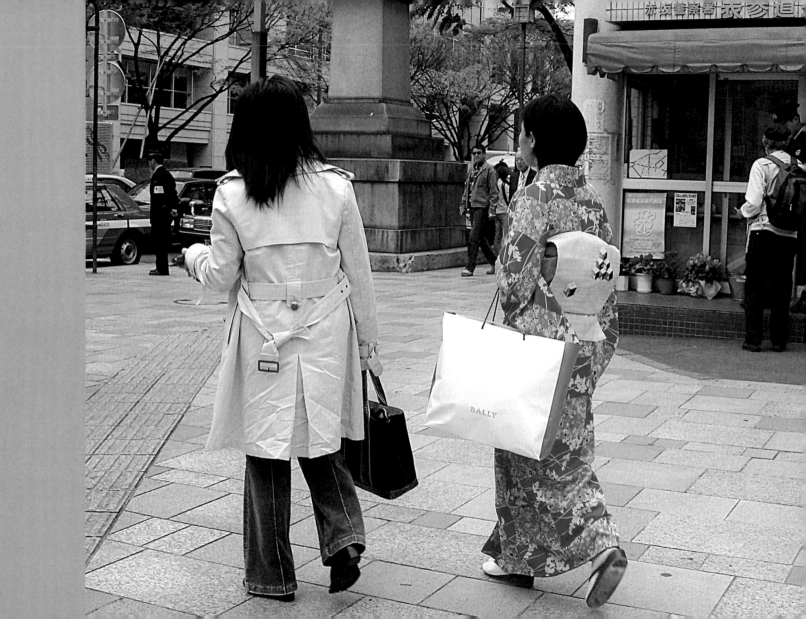

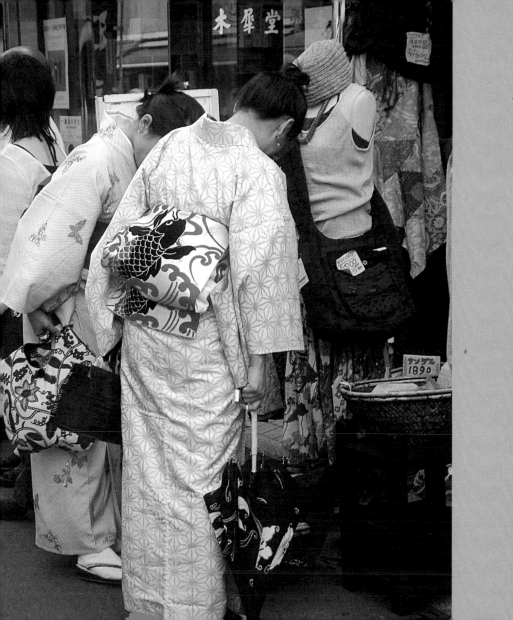

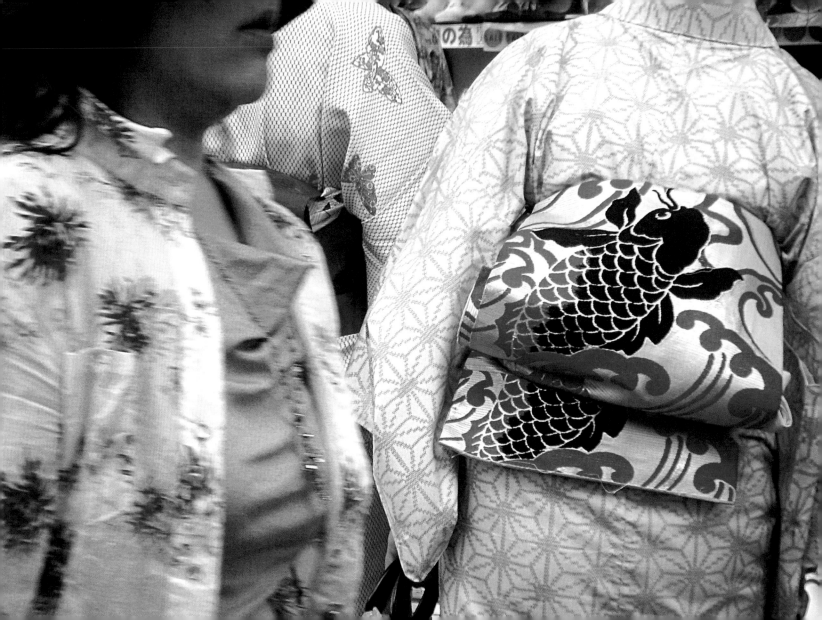

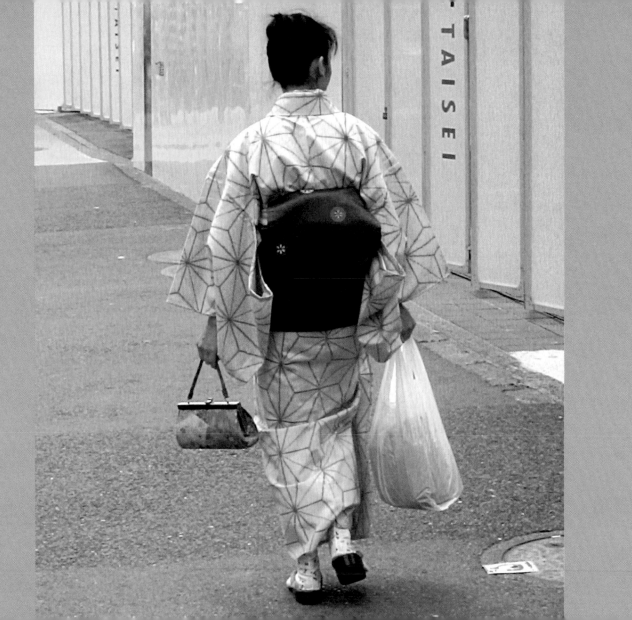

A woman in a kimono is like a fleeting vision. She emerges briefly from the crowd only to vanish, dreamlike, around a street corner. She evokes the ephemeral beauty so revered in Japan. Because of the geographical position of their island, the Japanese people know their whole world may founder in the blink of an eye. Frequent earthquakes remind them constantly of its impermanence. Perhaps it is this acute awareness that has developed a strong taste for fragile and ephemeral objects as well as for materials burnished by time. Hence their love of the cherry blossom, which shows for only a couple of weeks each year. Perhaps kimonos, now so rarely glimpsed in Japan, are in their eyes all the more precious for that.

summer

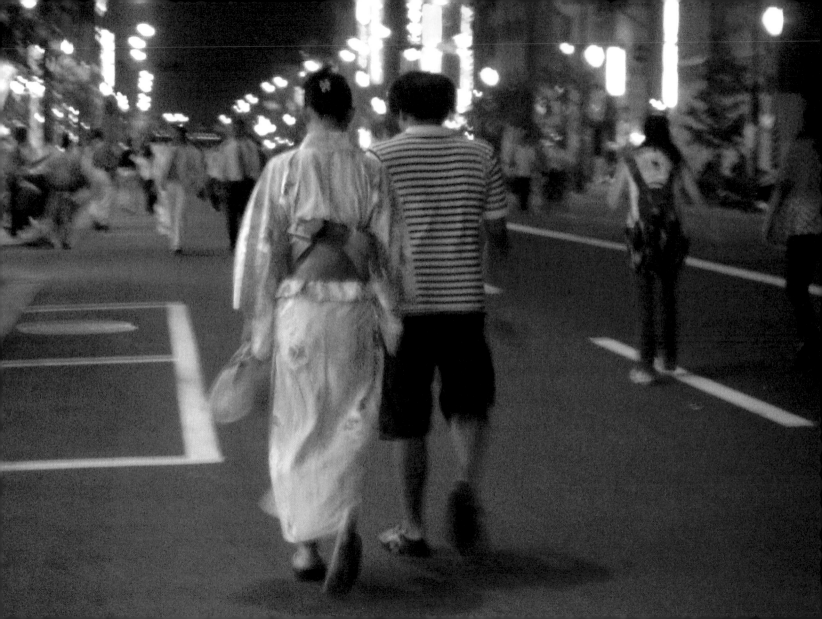

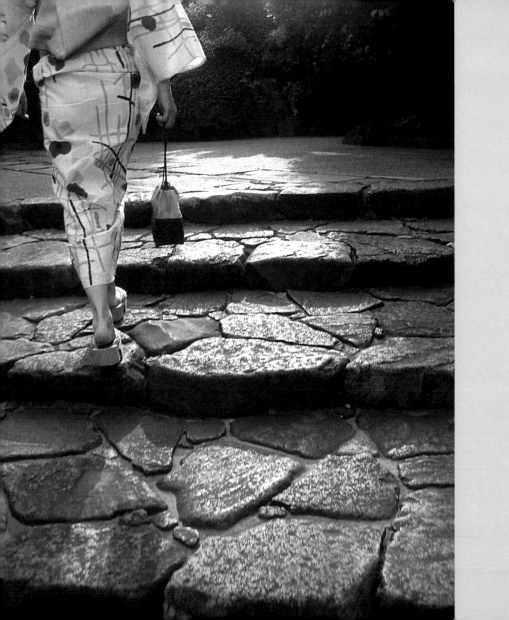

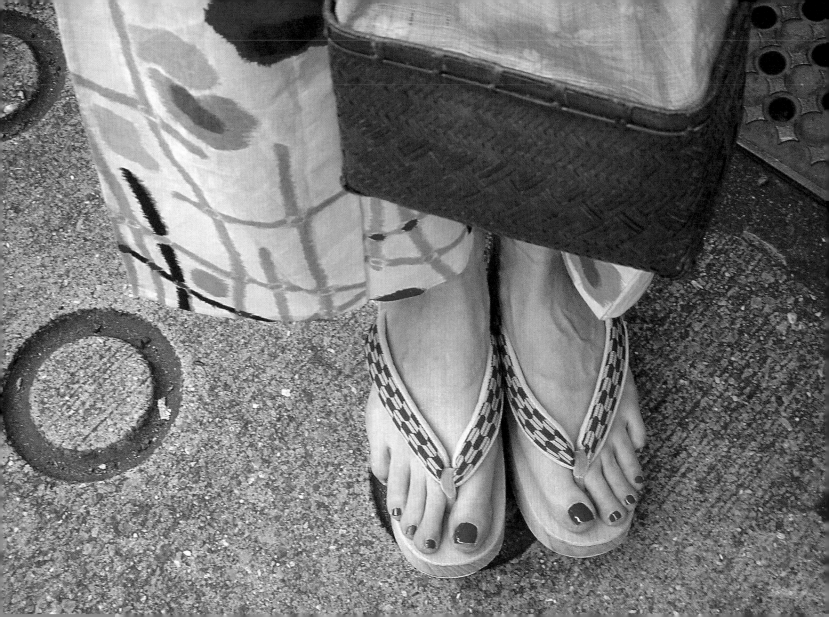

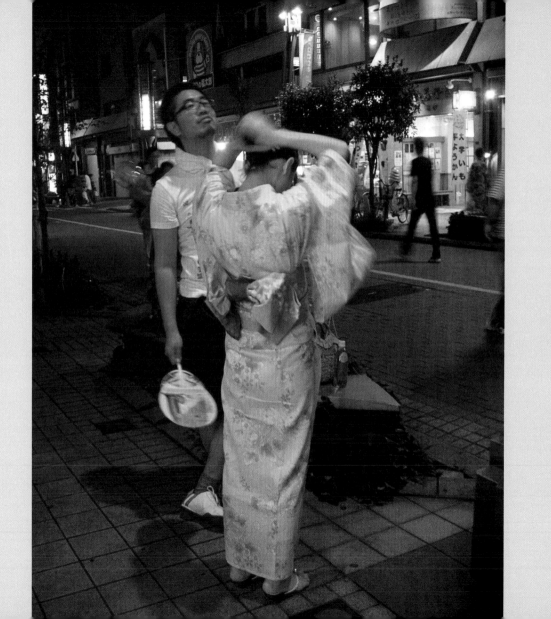

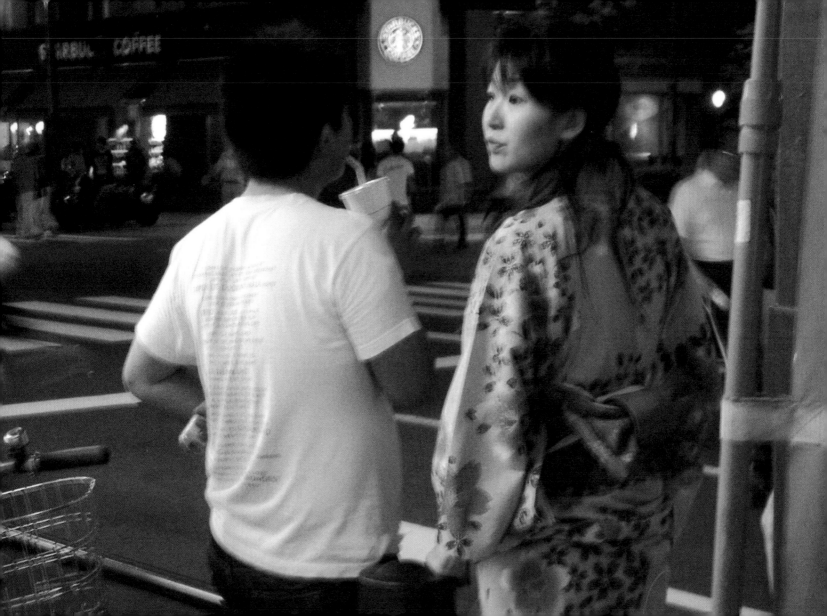

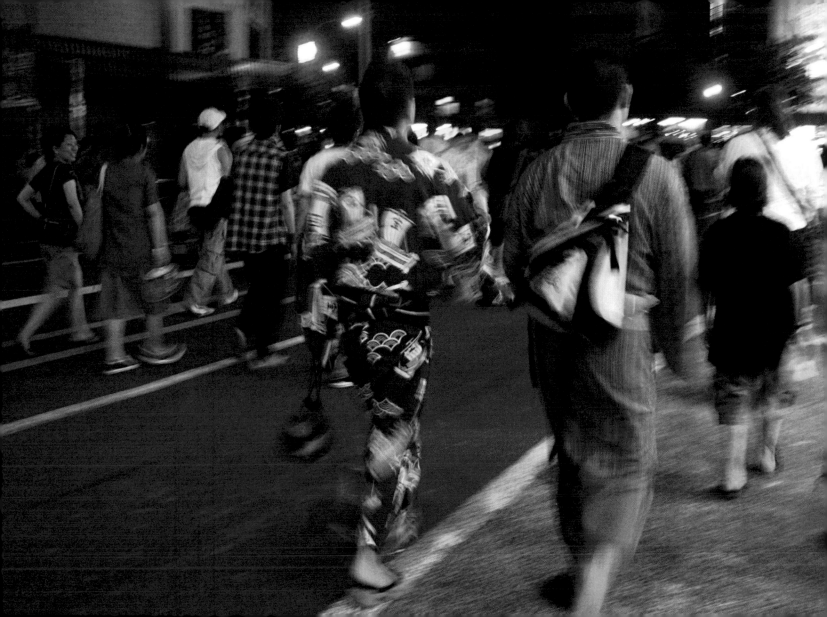

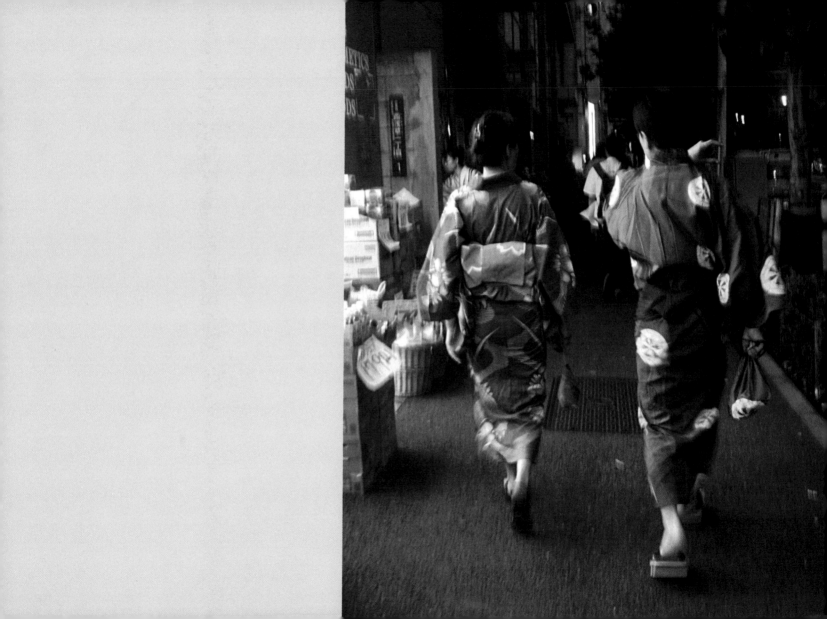

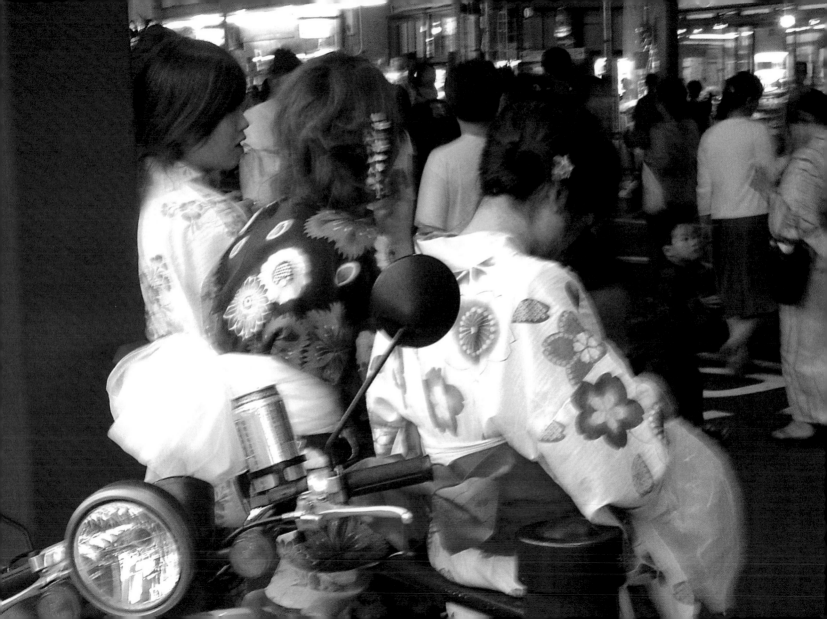

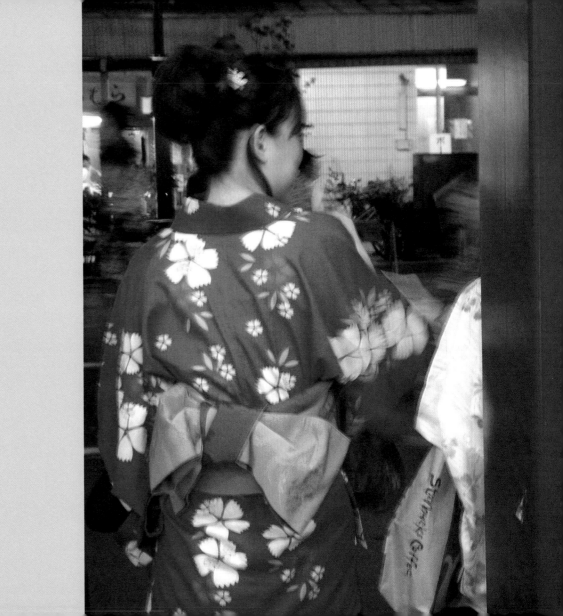

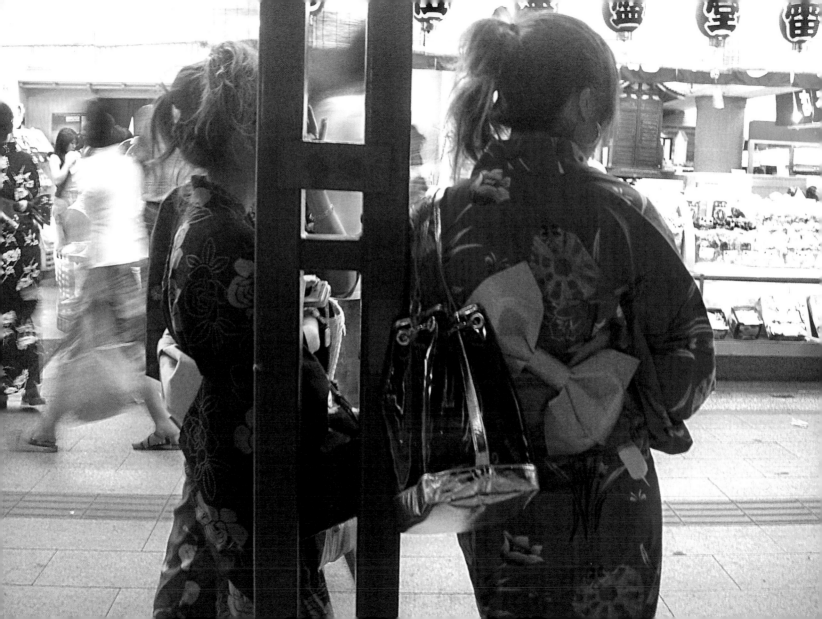

During the summer festivals, fireworks blaze in the skies above Tokyo, but for Westerners the real spectacle is terrestrial. The younger Japanese have put on the *yukata*, the light cotton kimono of the summer months. An explosion of colors and bright motifs hits the street. This is also one of the few times of year when men in kimonos are out in force. Their *yukata* are blended with the accessories and habits of the modern world, often creating droll contrasts. The girls still have their everyday hairdos, jewelry, and handbags; they walk along with modern accoutrements in their hands. Some keep faith with their Western clothes, and amid the crowd T-shirts with hip graphics consort with the flowered prints of kimonos and obis.

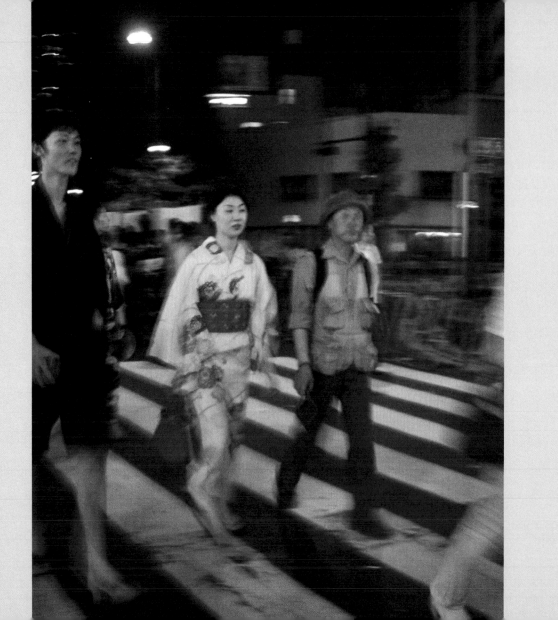

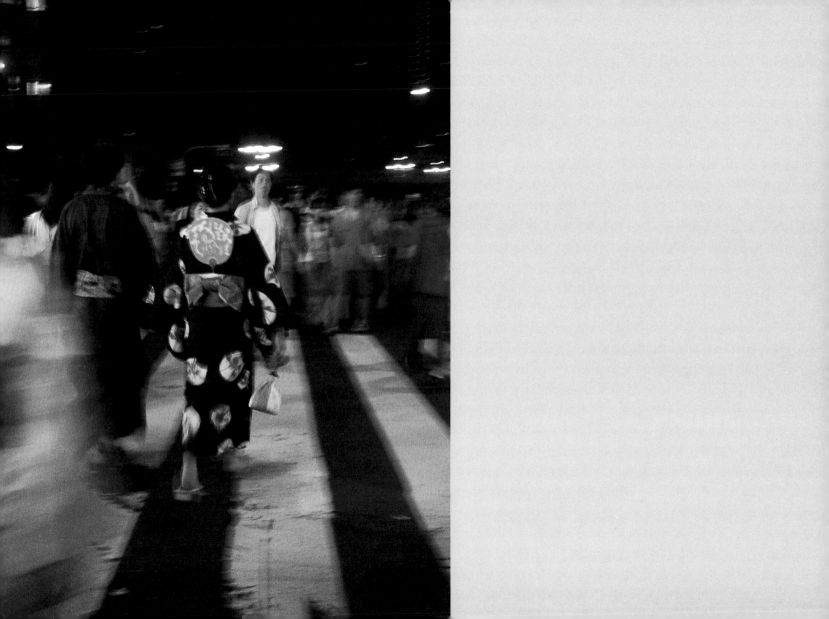

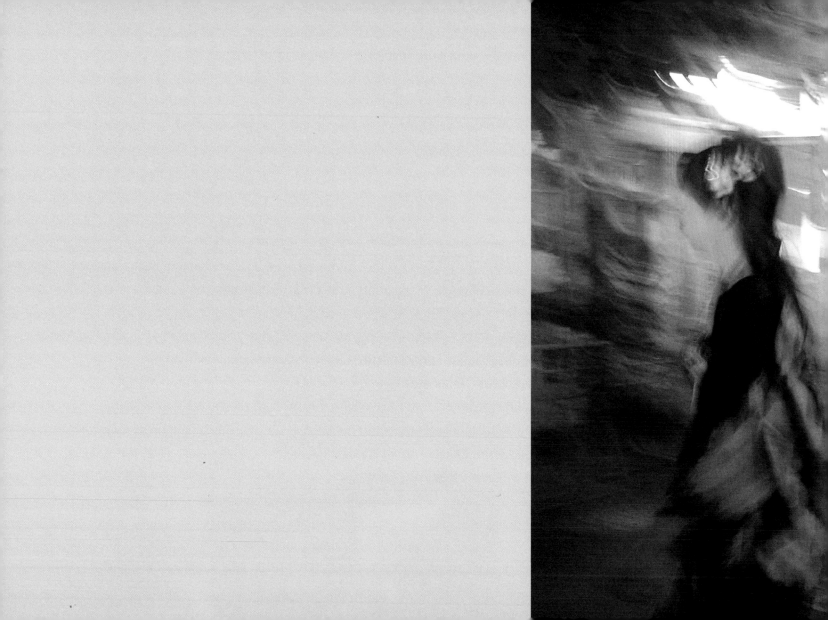

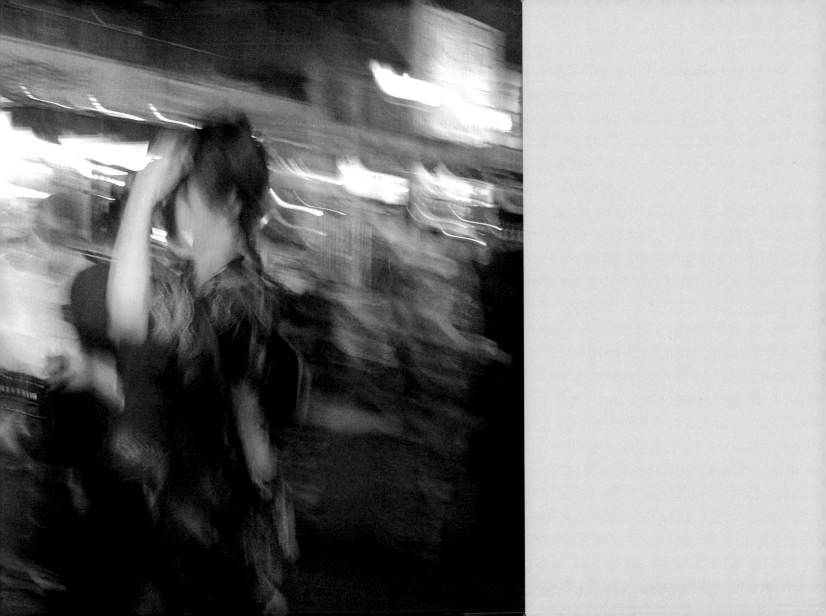

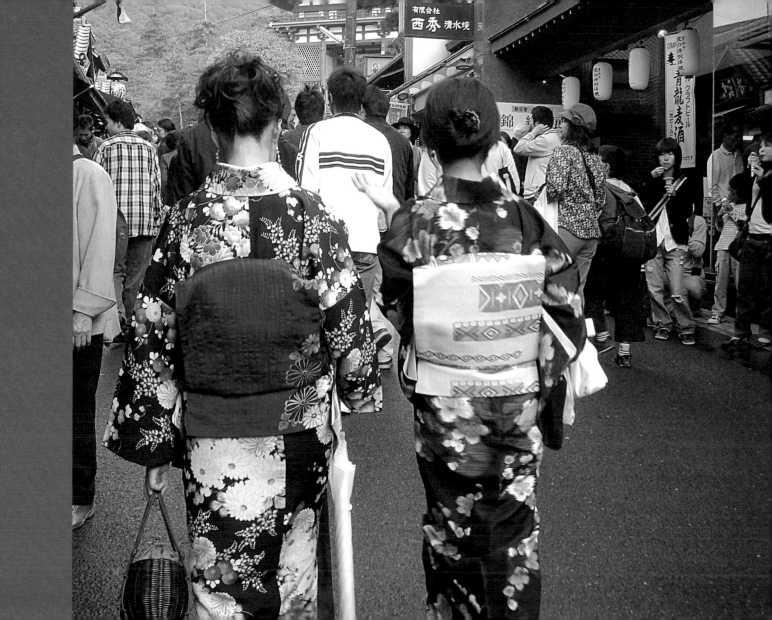

fall

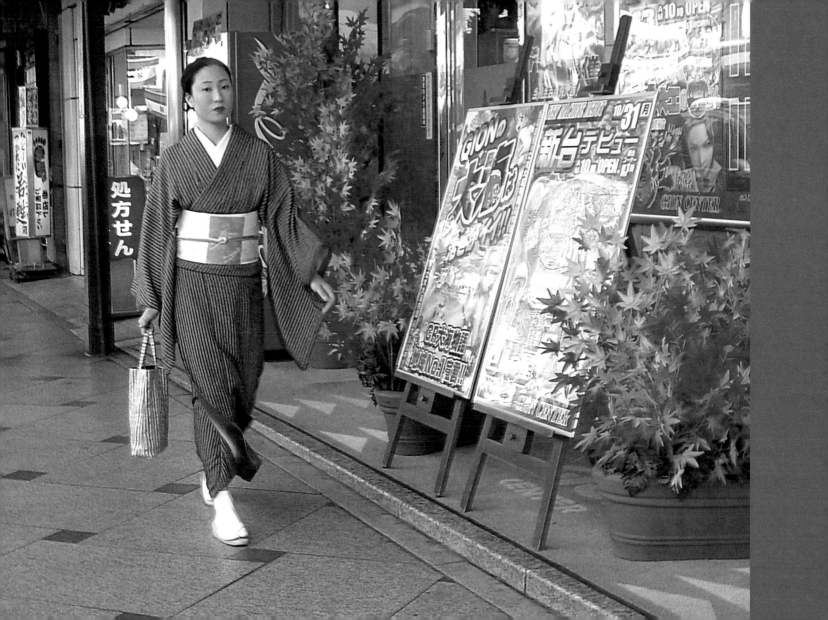

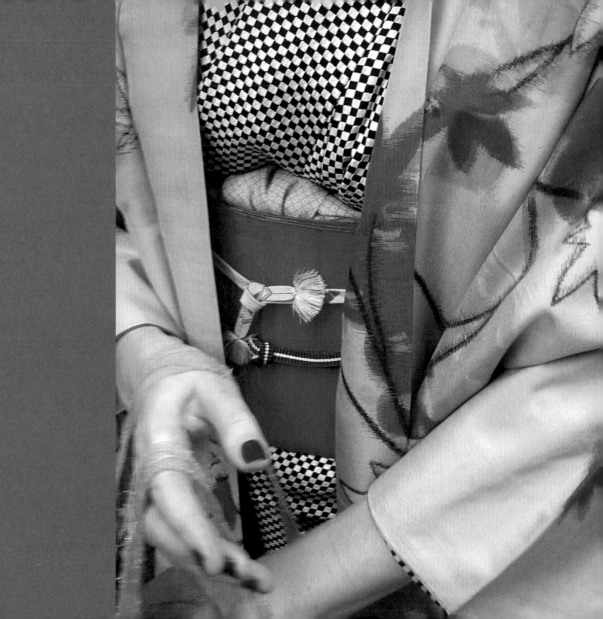

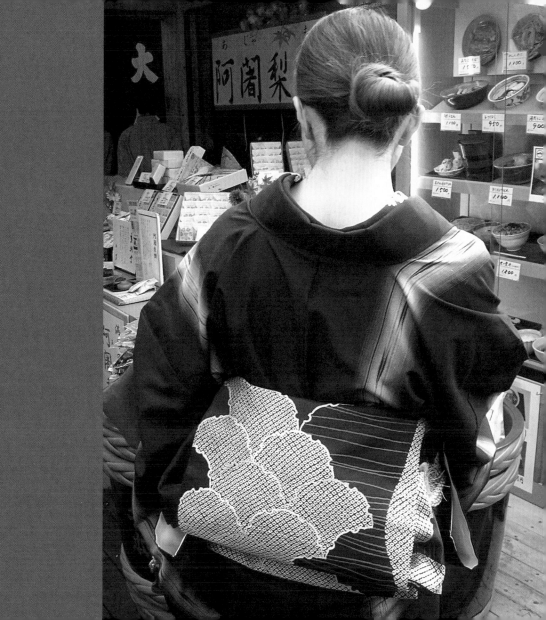

Wandering among the beautiful Tokyo girls in their kimonos, I am reminded of Yohji Yamamoto's remark: "I don't know why, but I'm always moved by the shape of a woman seen in profile or from behind. It's like a need to catch hold of something that's passing me by and disappearing. The scent of perfume in a woman's wake produces a similar frustration. My love of women is like a longing for the unobtainable. In my eyes a woman is someone leaving, someone who disappears. That's why the back—*her* back—is so important to me. I think one should make clothes beginning with the back and not the front. The back carries the clothes; if it's not perfect, the front doesn't exist."

In Japan, in the presence of so many obis, of so many lovely napes beneath piled hair revealed by the kimono's backward fall, I can only agree.

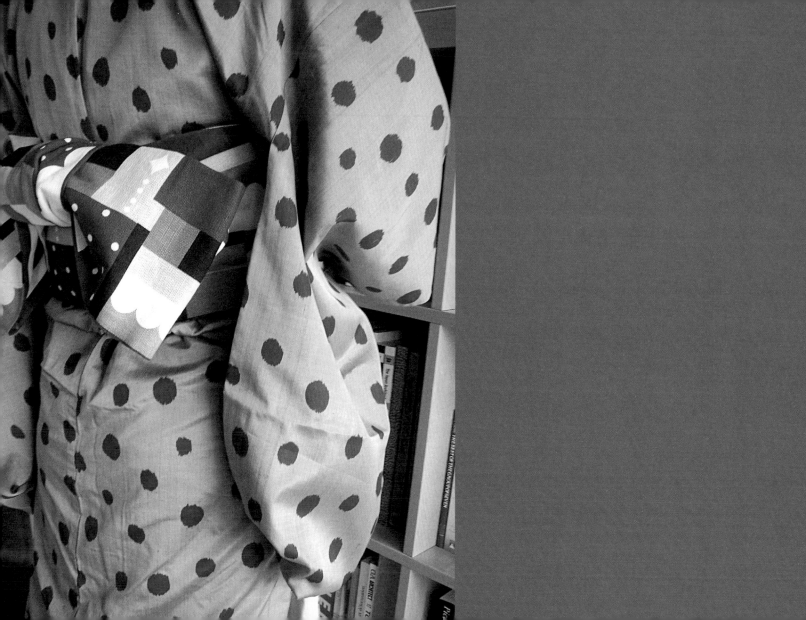

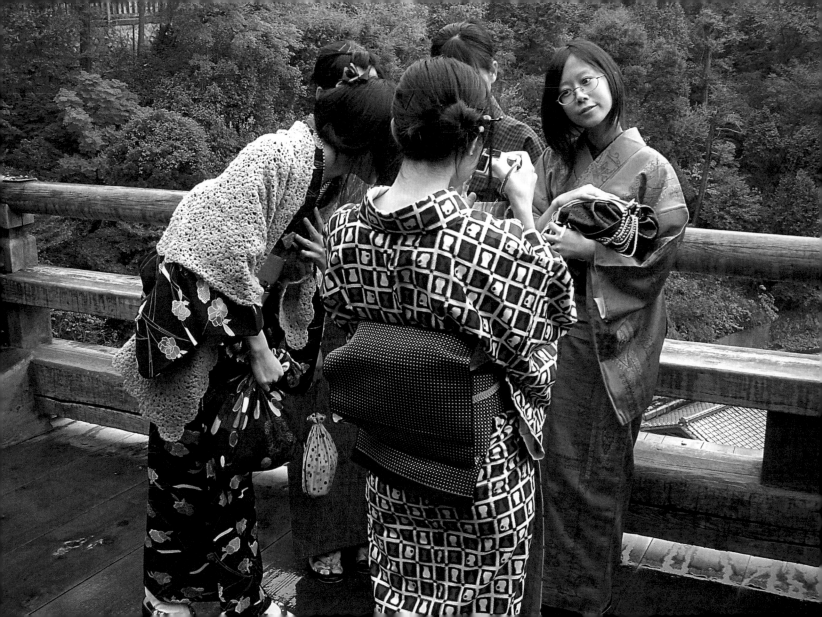

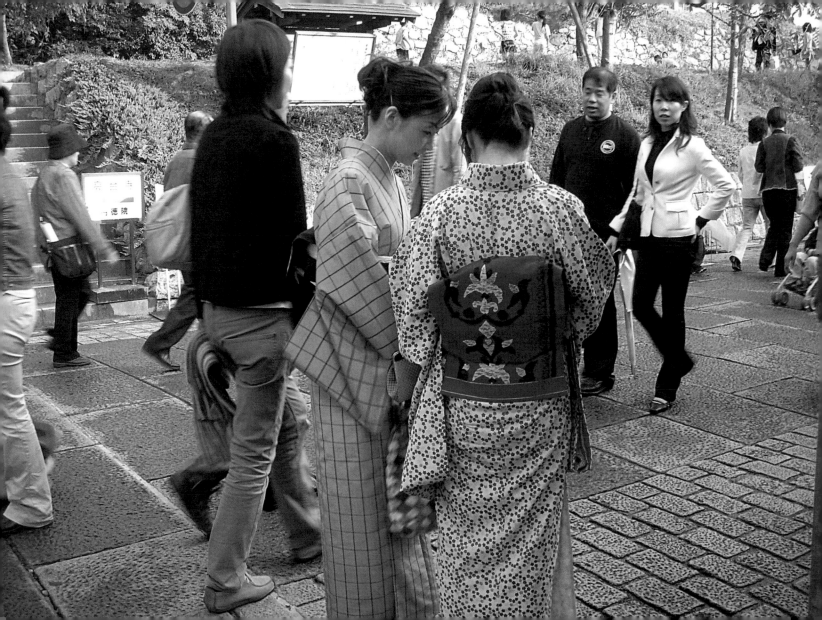

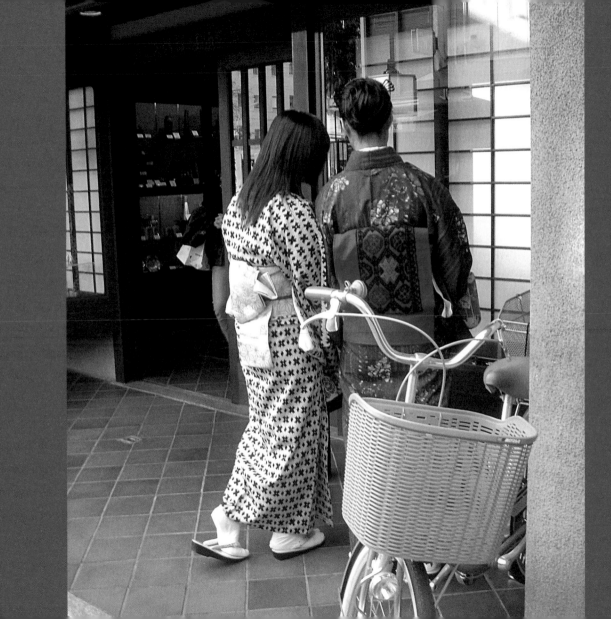

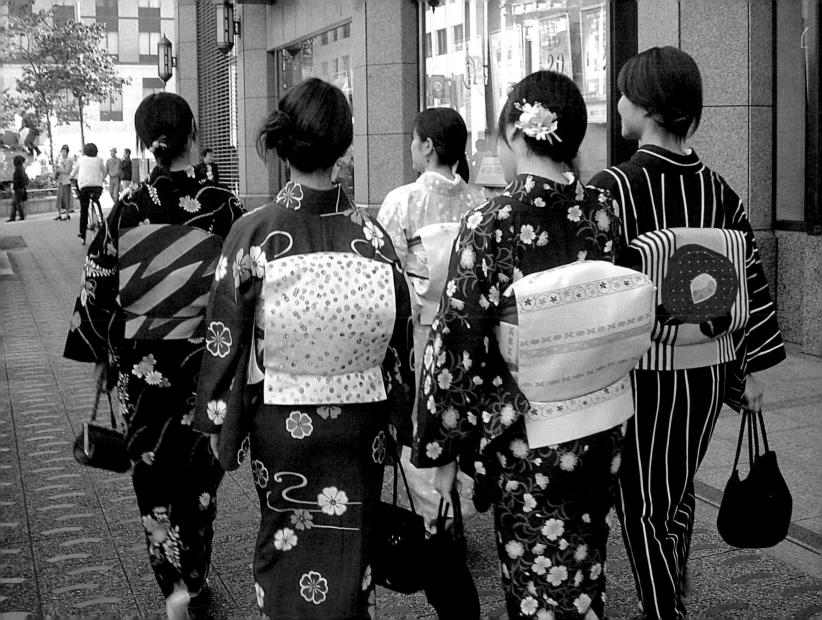

winter

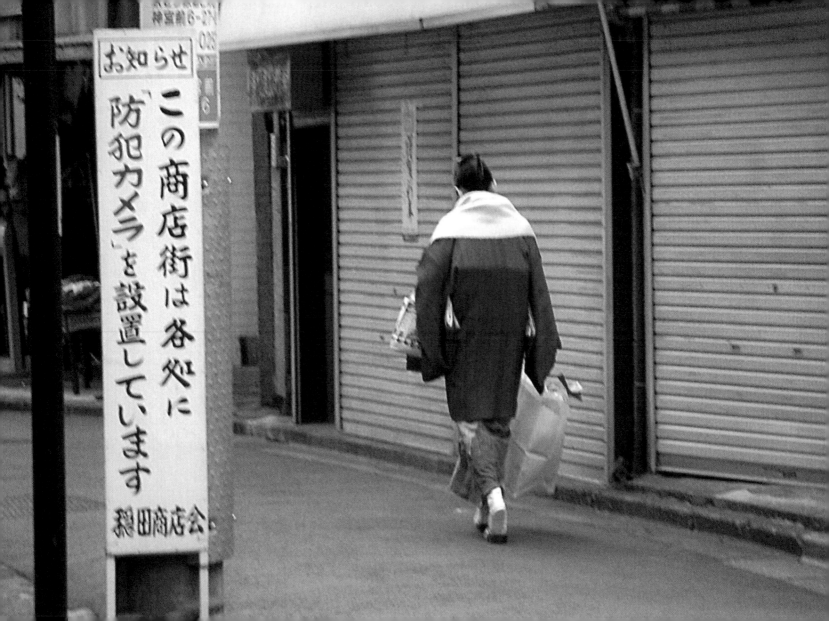

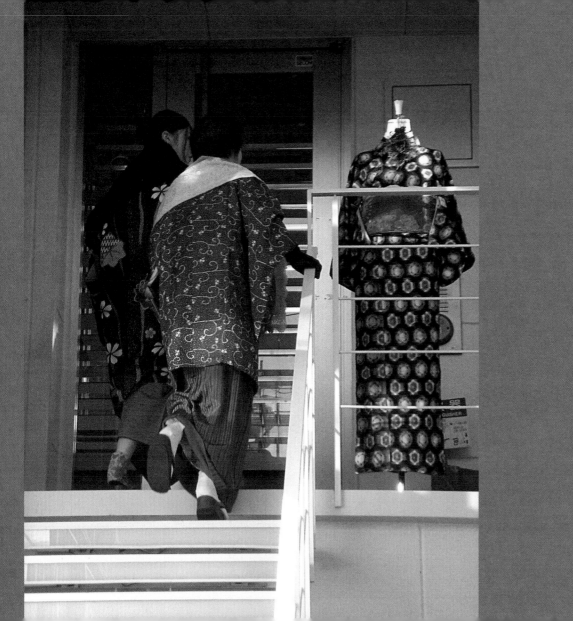

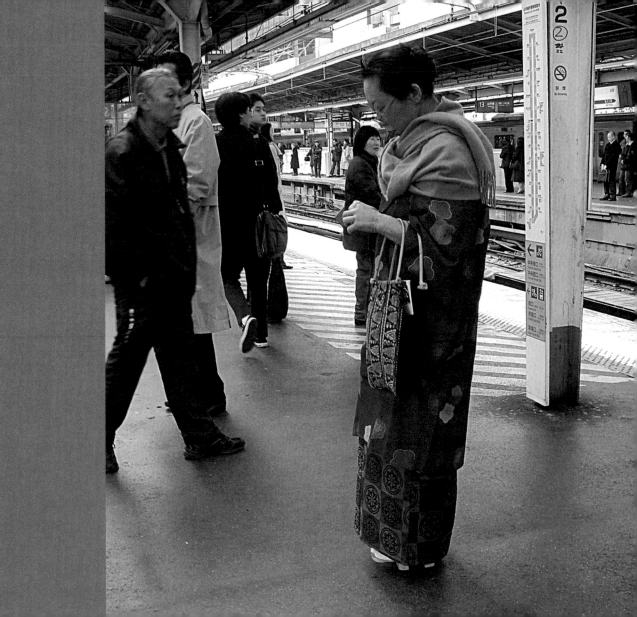

Kimonos are worn in winter and summer, in the harsh winters of Hokkaido and in the tropical heat of Okinawa, and at first sight the differences between them seem slight enough. But while their shape is identical, the materials are entirely different. Winter kimonos are lined with silk, which against all expectations turns the floating, semitransparent dress of summertime into something that can keep you as warm in January as it keeps you cool in August. More layers are added as the temperature falls. The *haori* appears, a short or mid-length coat beneath which the obi makes a curious swelling. With this come woolen stoles, scarves, and fur collars, while the mixes of motifs and colors bring a note of gaiety to the winter landscape.

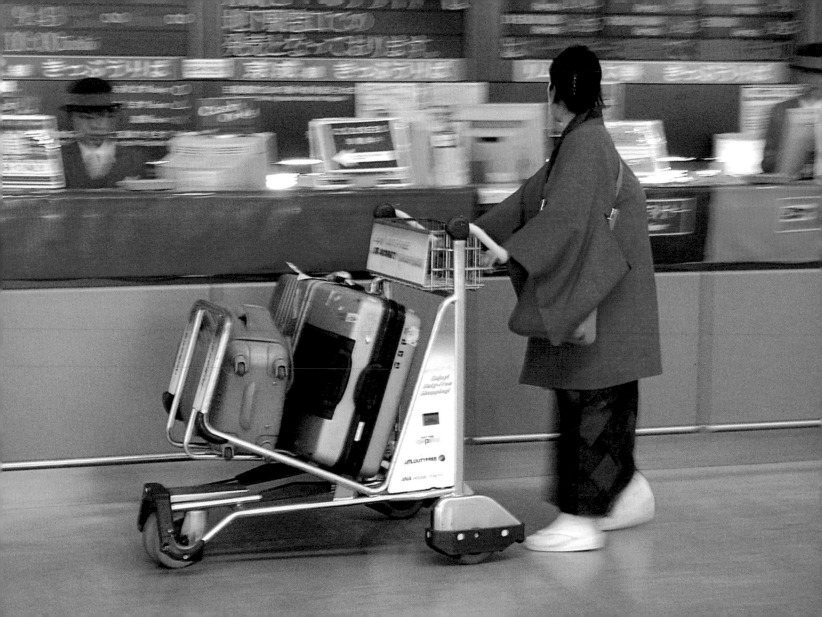

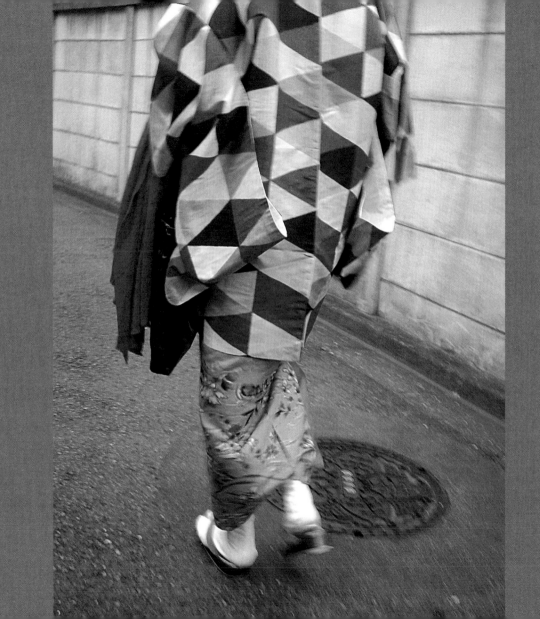

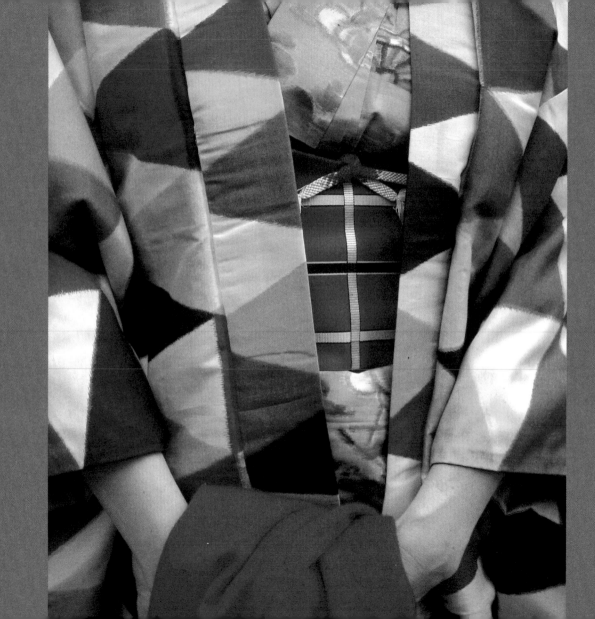

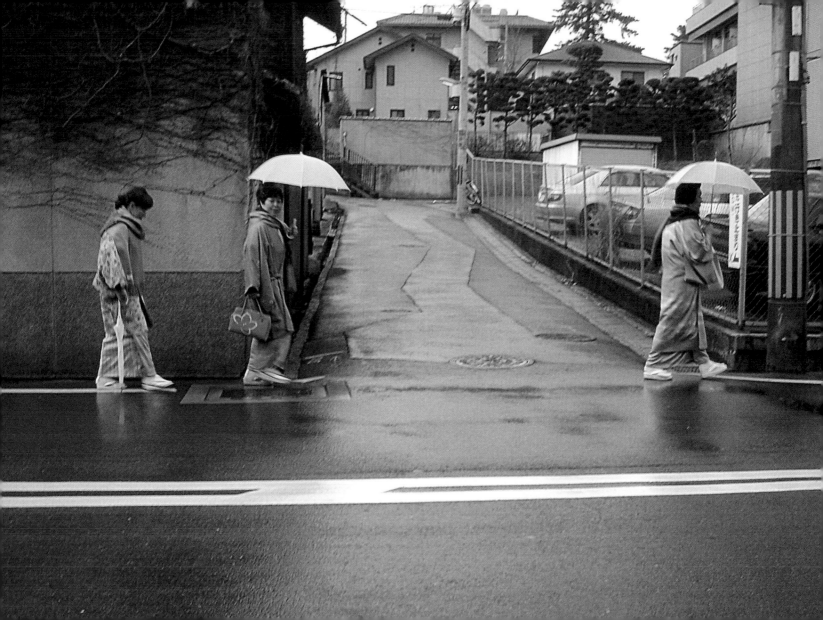

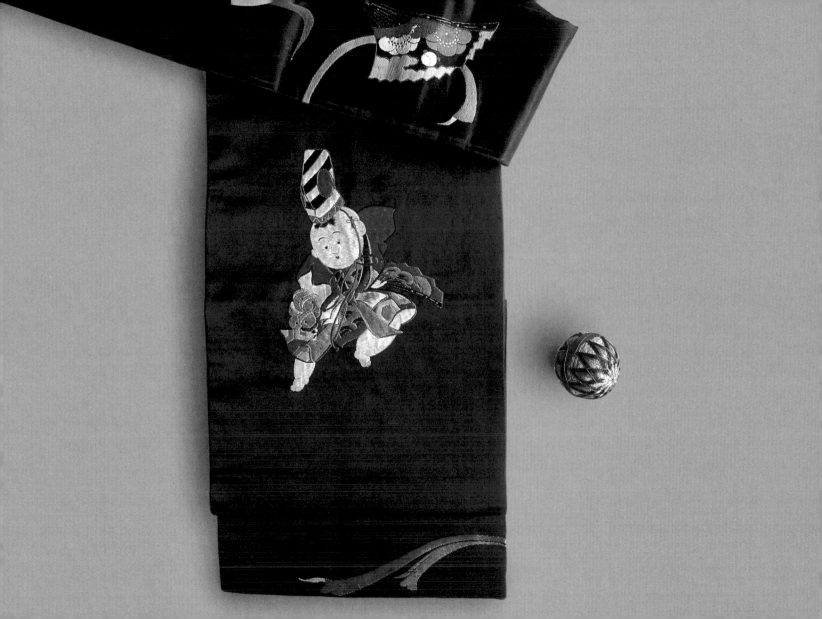

In Japan, as in all other human societies, the different stages of life are marked by celebrations. Childhood, coming of age, mature adulthood, and times of mourning all require the wearing of a particular kimono. For women the changes are emphatic and precise.

Marriage is a key moment; it marks the end of long-sleeved kimonos and saturated colors. The more women advance in years, the more muted the tones and motifs of their kimonos become. Eccentricity is no longer an option. In this, the Japanese have merely imposed an exact code on a procedure that is tacitly but nonetheless rigidly applied in many other countries of the world.

tradition

shichi go san

In the month of November, girls of three and seven years old and boys of three and five years old are dressed in traditional kimonos and taken to the temple to be blessed with long life. Parents and grandparents go with them. They hold the little girls' hands as they teeter up the temple steps in their *zori* (thonged Japanese sandals); then push them proudly forward to be photographed by fascinated tourists. In the perpetual building site that is Tokyo today, the rich costumes of the children are sometimes seen against the most incongruous backdrops.

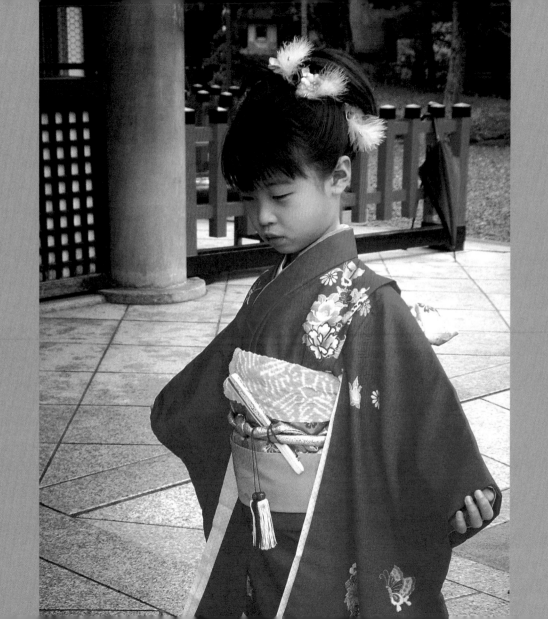

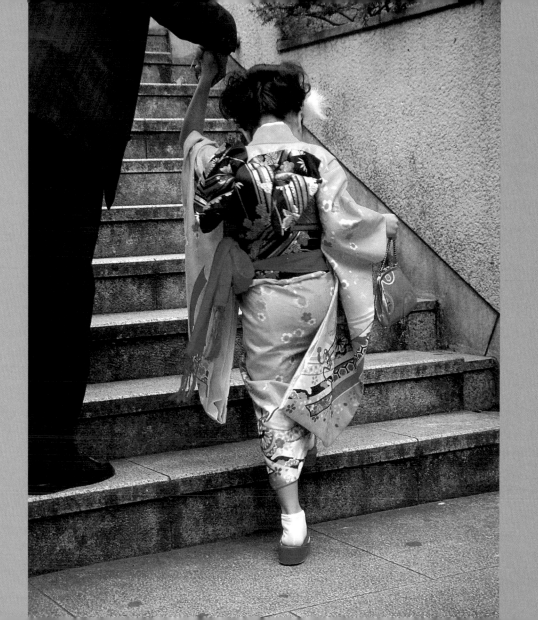

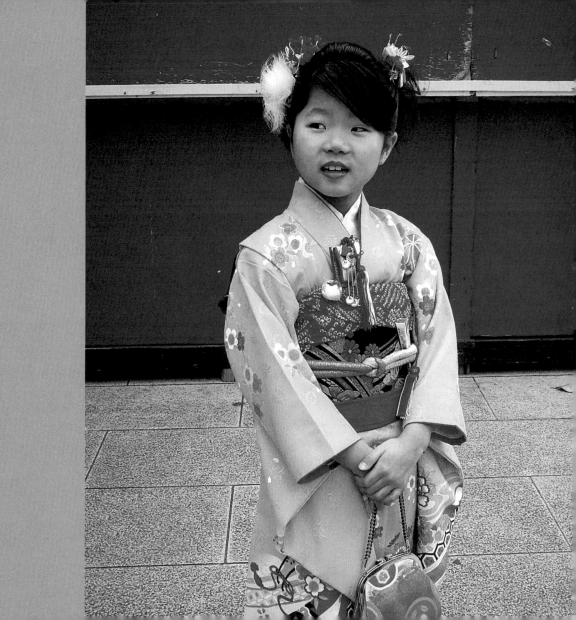

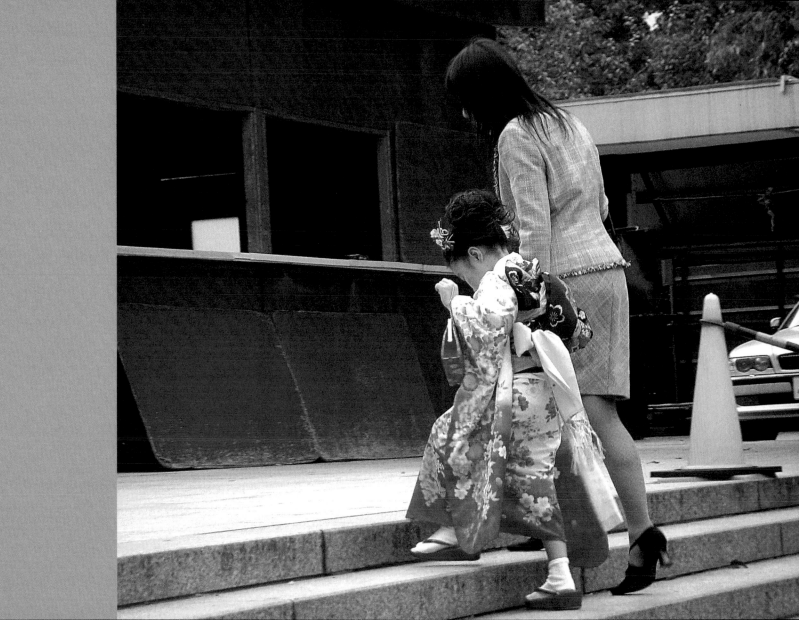

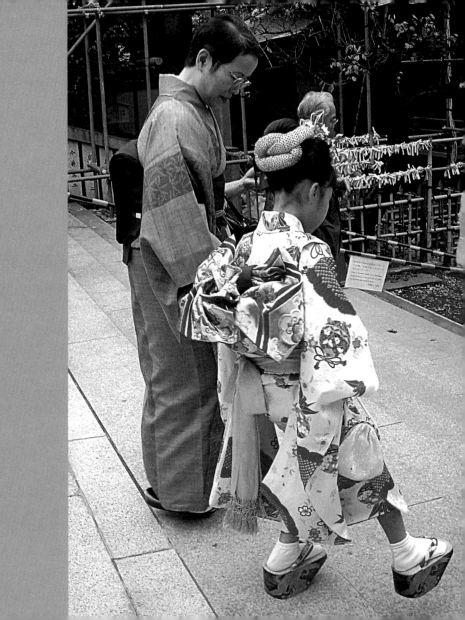

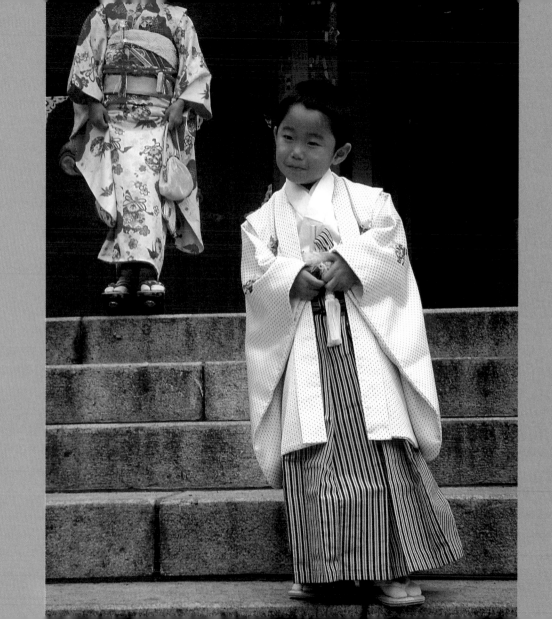

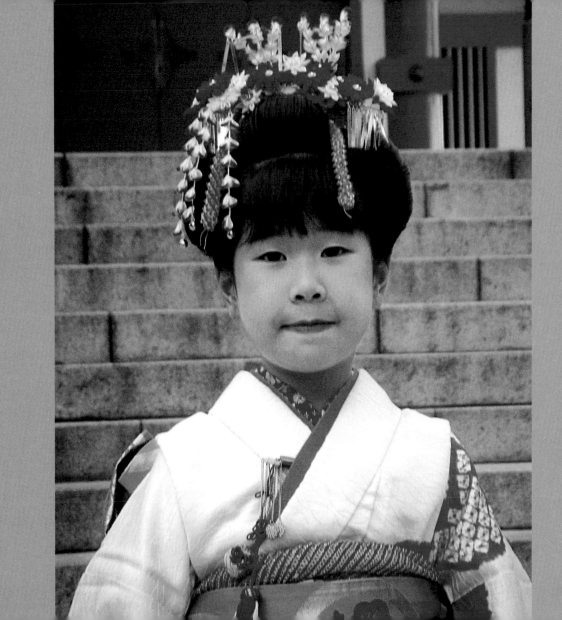

seijin shiki

On the second Monday of January, the feast of *seijin shiki*, girls who will reach the age of twenty in the coming year put on the *furisode*, an exceptionally long-sleeved kimono with an obi that has a large flower-shaped knot, and a fur stole. This date marks their coming of age and it brings with it all the rights of adulthood. From daybreak onward, they throng the streets and temples, delighted and tremulous queens for a day. As the groups of girls parade around, their flamboyant, showy *furisode* add a touch of the dreamlike to the urban scene. Next day, of course, the city will be as gray and humdrum as ever, and one will wonder if it was indeed a dream.

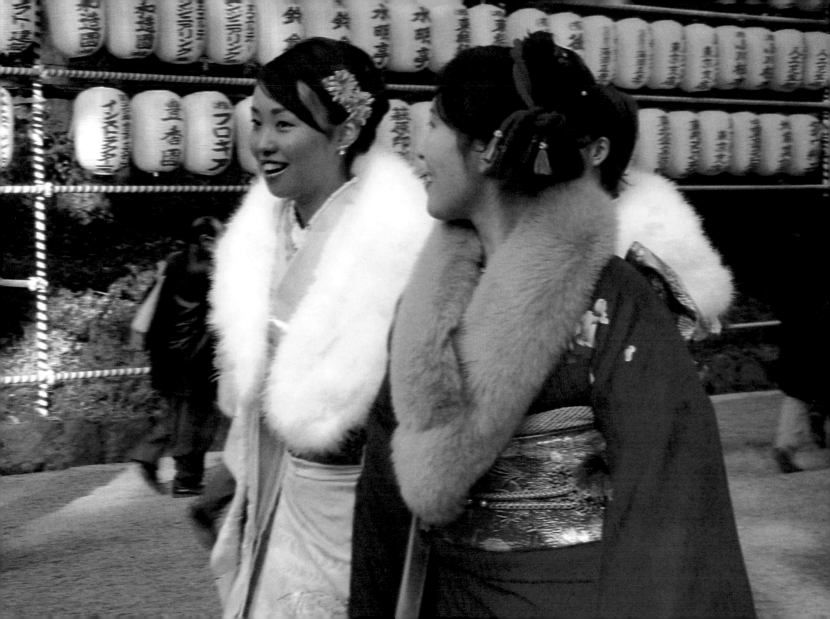

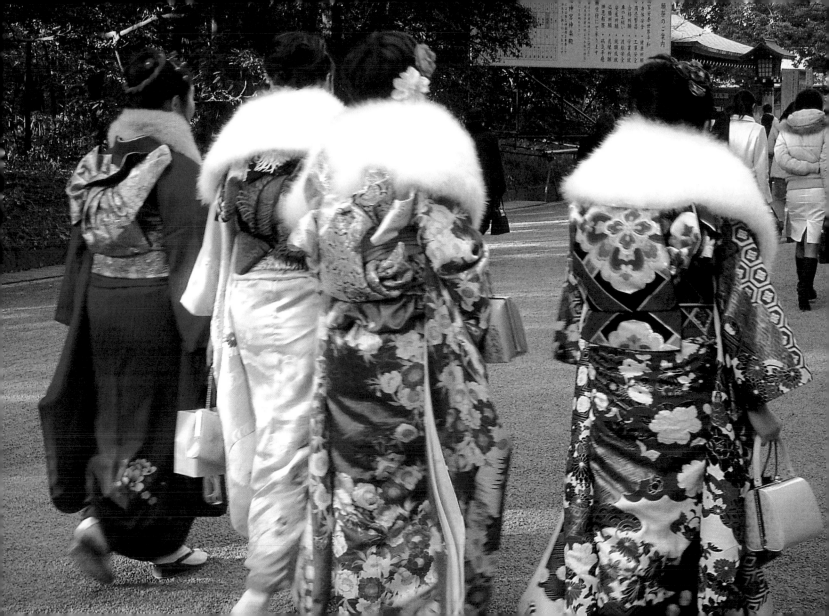

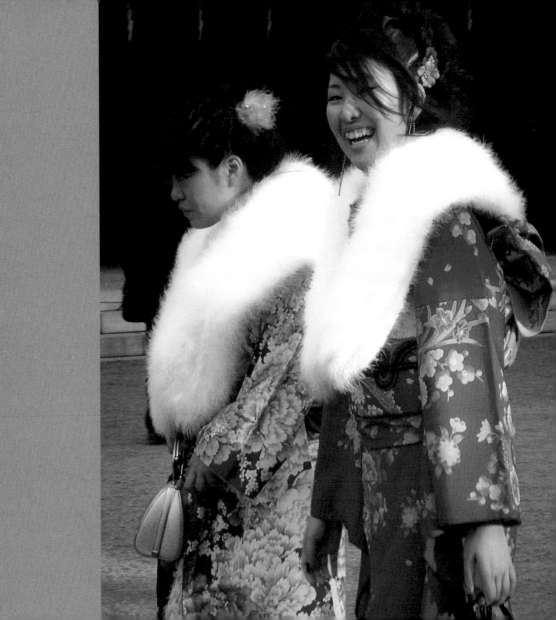

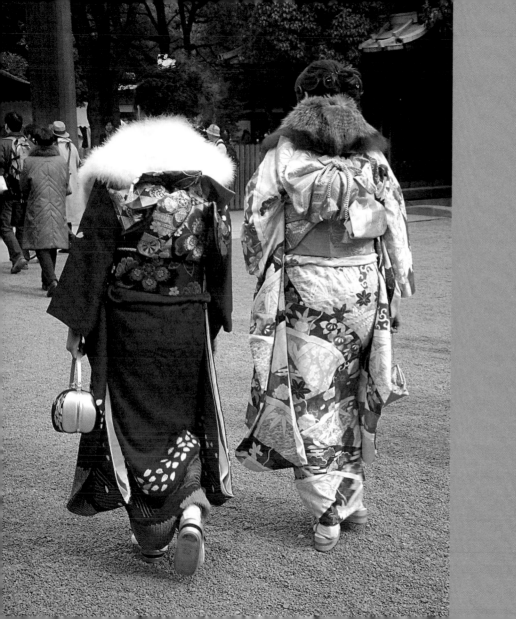

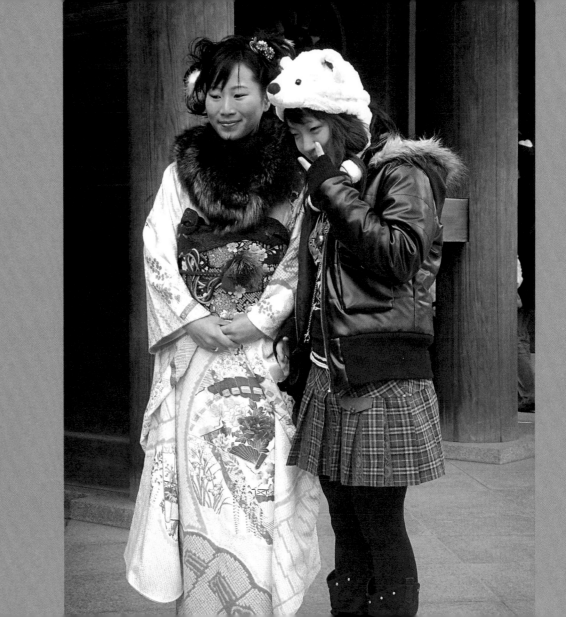

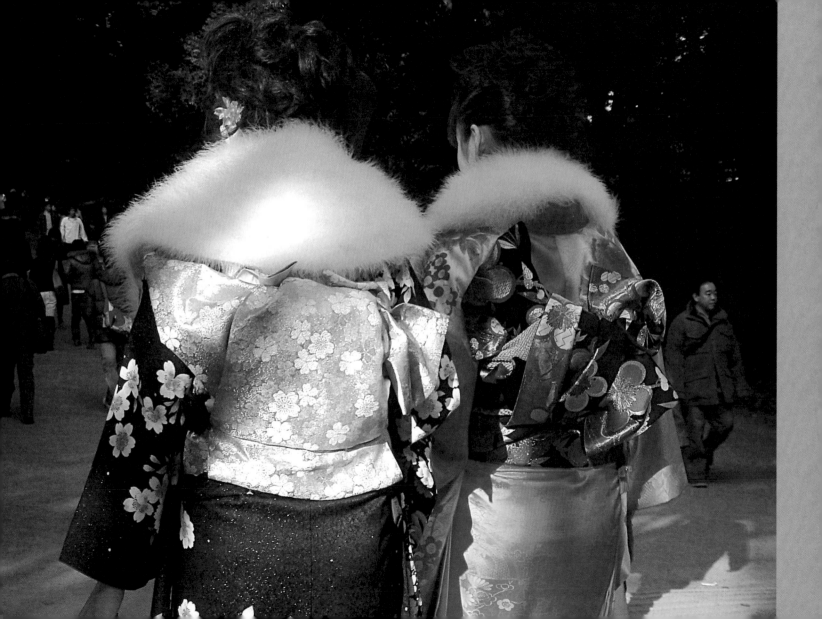

marriage

According to the traditional marriage ritual, the bride dons at least two different kimonos in the course of her wedding day. During the religious ceremony, she wears a white kimono covered with a voluminous cape. White is the color of mourning in Japan; at a wedding, it signifies that the bride is dead as far as her own family is concerned; from now on she belongs to the family of her husband. Afterward she changes into a richly decorated kimono, with the color red predominating along with black and gold. Soon, however, her status as a wife will oblige her to give up the bright tones and long sleeves of the *furisode*, while her husband retreats into a discreet harmony of black, gray, and white. A *kamishimo*, a kind of pleated skirt, is worn over his kimono, and his *haori* bears his family's coat of arms.

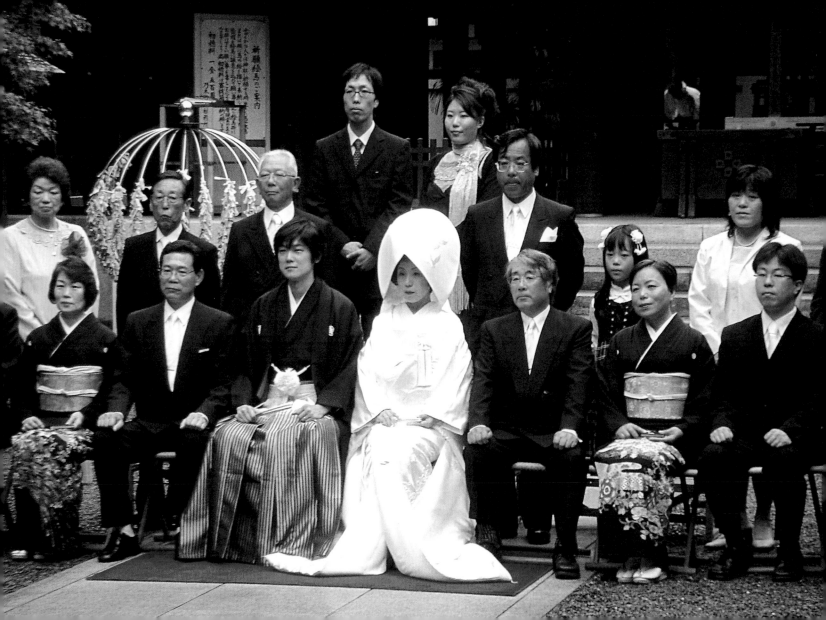

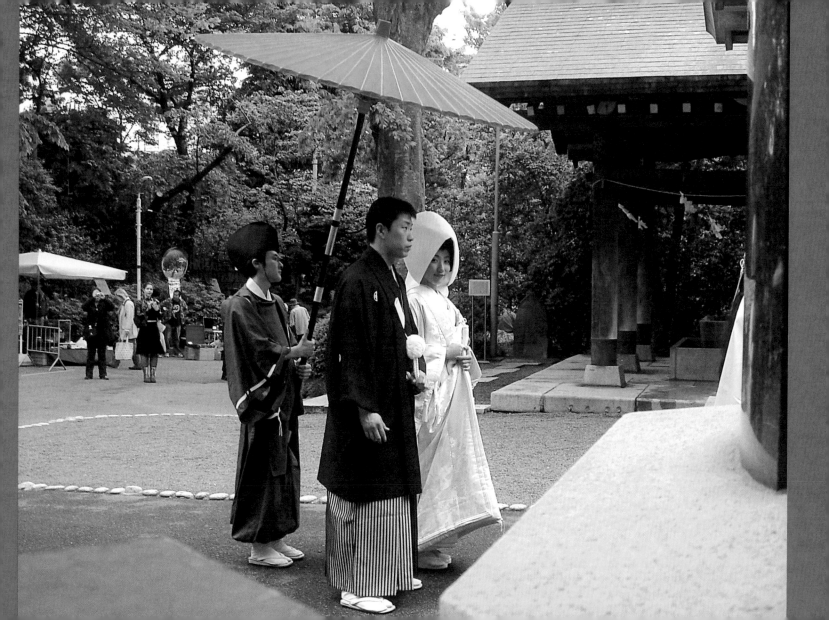

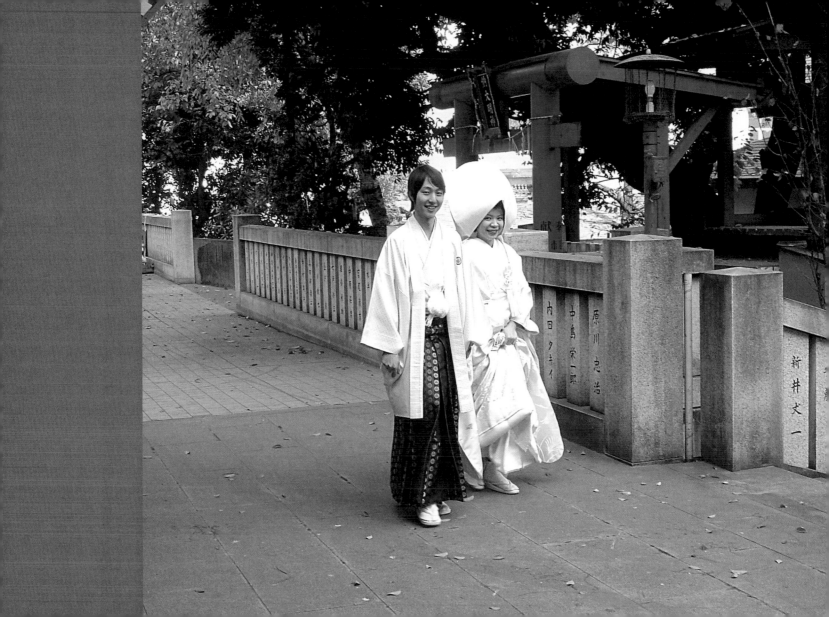

The bride wears a curious hat, which is supposed to protect her against the horns of jealousy.

The wedding couple's immediate family dress in black, with the women wearing the *tomesode*, a formal black kimono with an ornate lower half and a family seal on the shoulders and back. There are approximately three thousand different seals in Japan; some families have possessed their own for several centuries, others merely select one by its meaning and for its affinity with their name. The seals are stylized vegetables or animals, usually set inside a small, three-centimeter-wide circle. Depending on how formal the ceremony is, the kimono may be printed with one, three, or five seals. They are always on the upper part of the garment, the first one in the middle of the back, the second two on the backs of the sleeves, and the last two in front, against the shoulders. One could spend many hours sorting through the details of these little seals, which are without exception small miracles of subtlety and graphic balance.

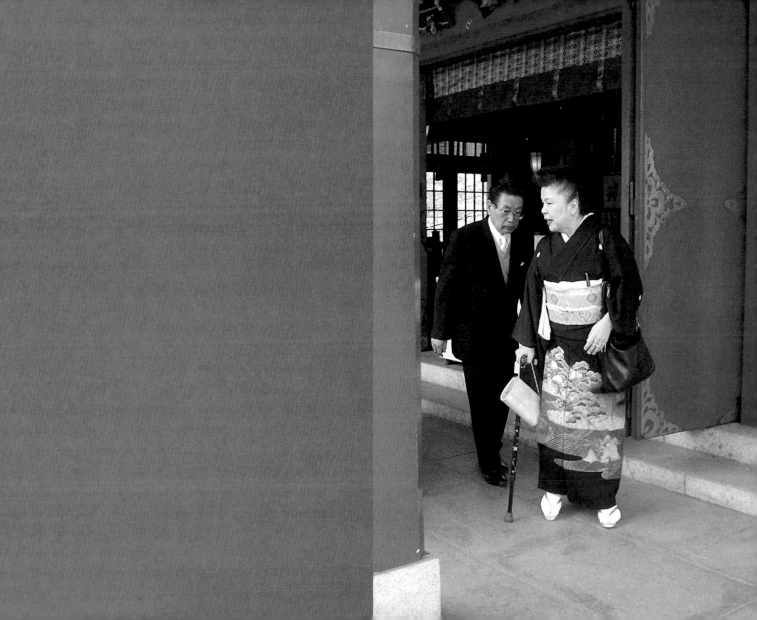

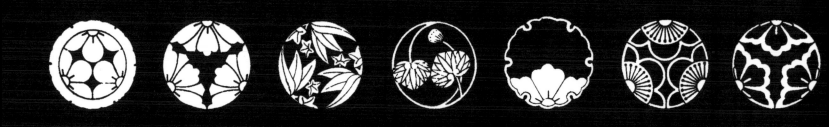

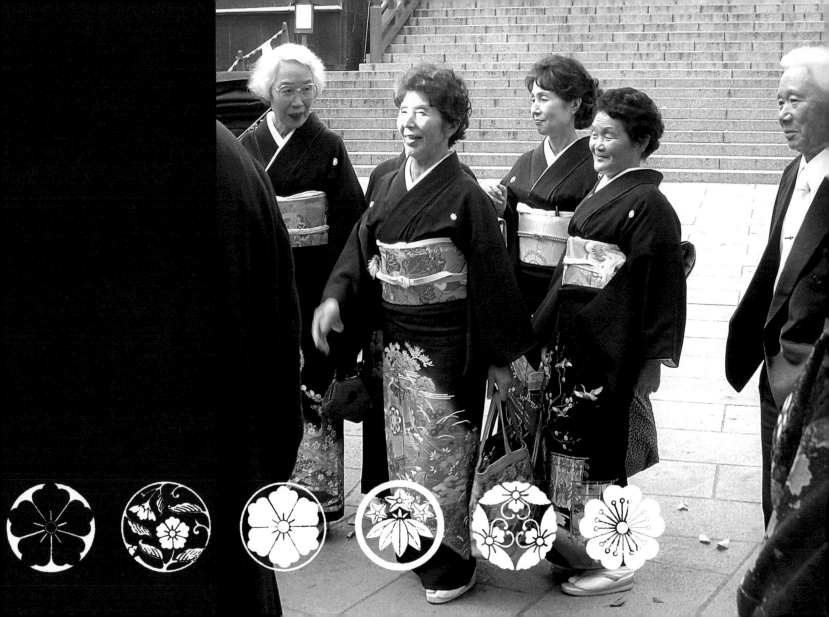

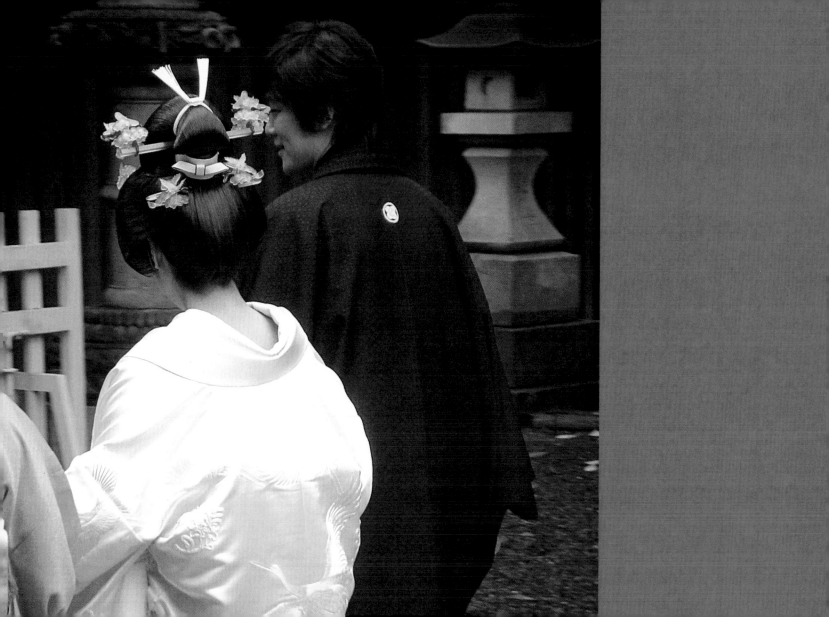

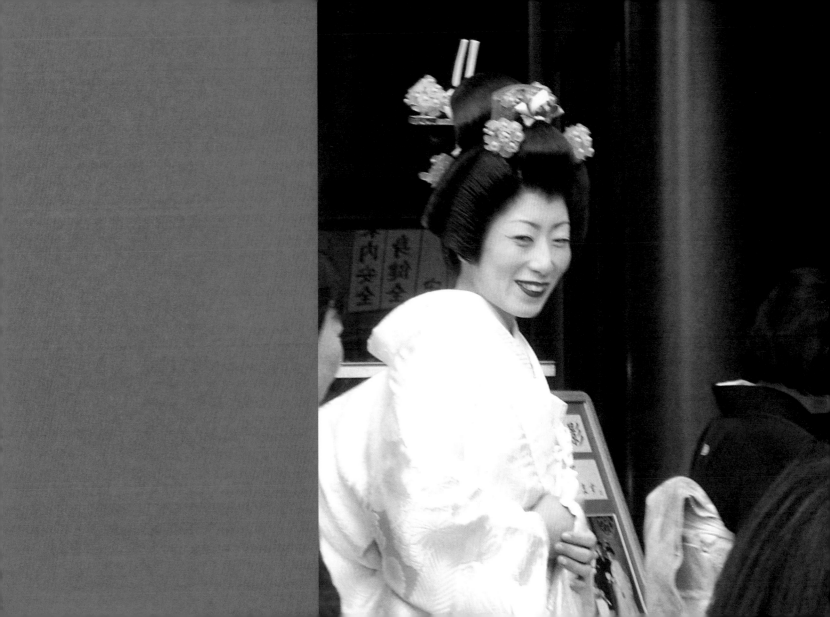

after the wedding

After marriage, women adopt progressively more discreet colors and motifs in their kimonos. The full range of pastels and shades of gray now come into play, with the palette growing more and more neutral as youth recedes. There is something ineffably sad about this effect, which seems to involve the slow renunciation of gaiety and lightness. But Japanese women approach it philosophically—with more wisdom, perhaps, than the youth-obsessed women of the West. They also compensate for the absence of vivid color in the subtlety of the weaves and prints they wear. And there is no reason why they should not add a touch of gold or silver to all this.

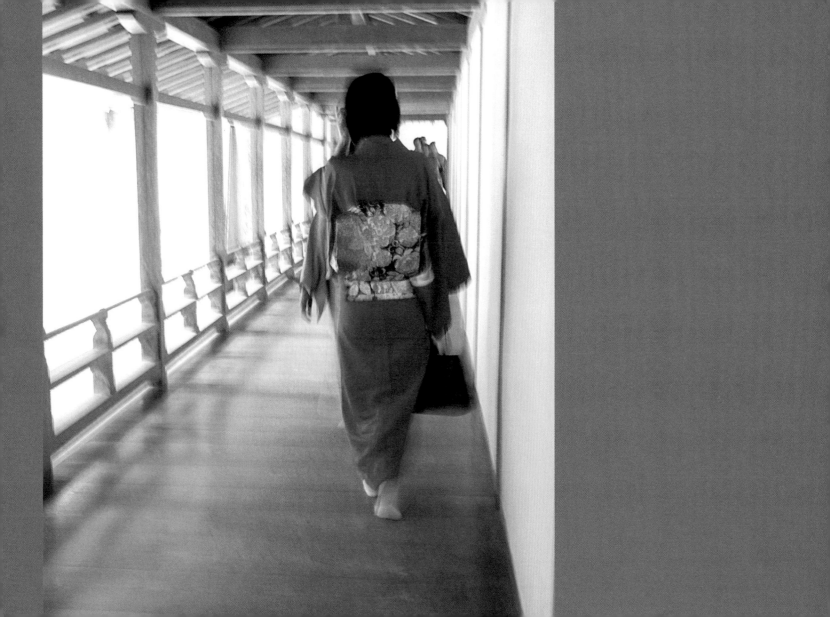

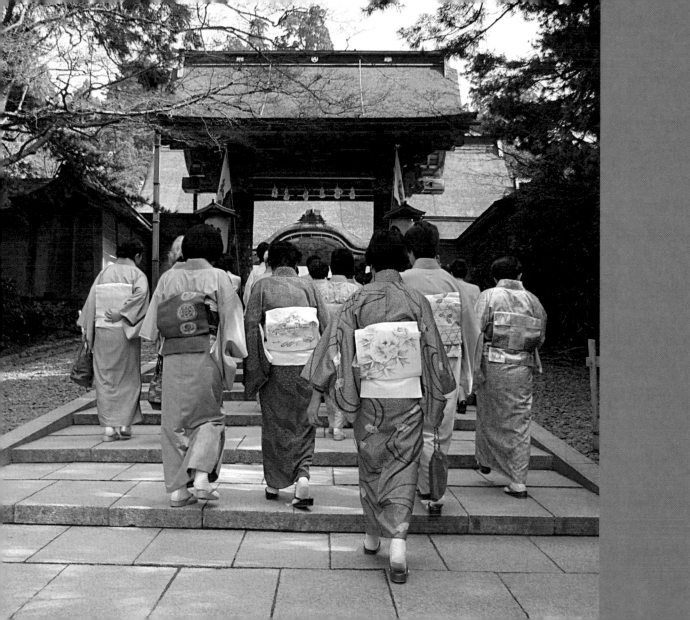

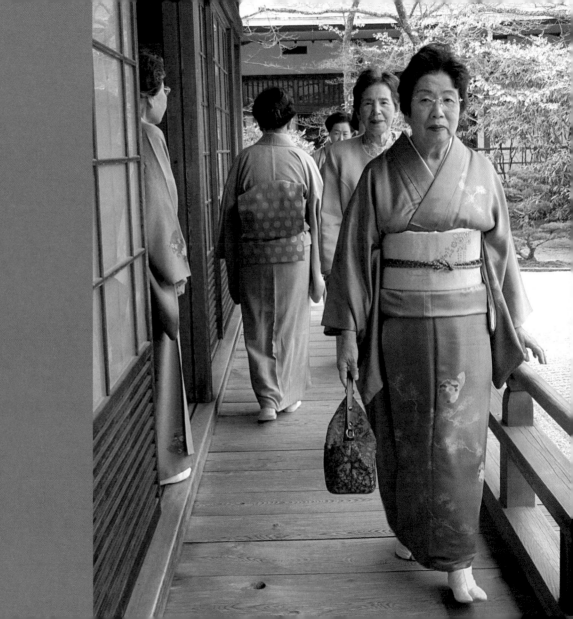

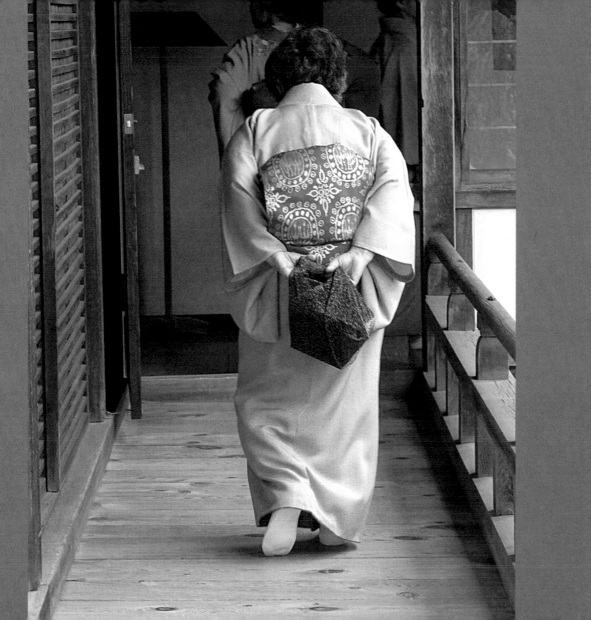

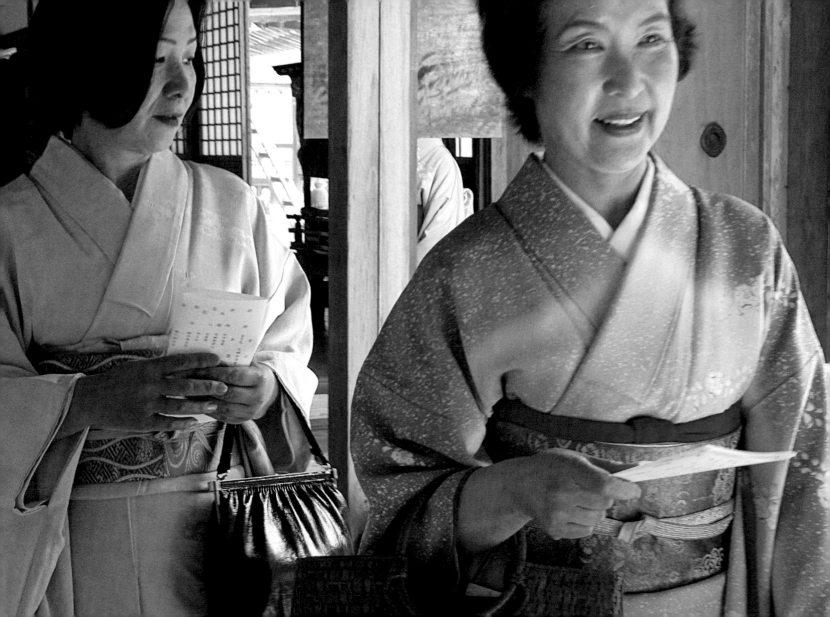

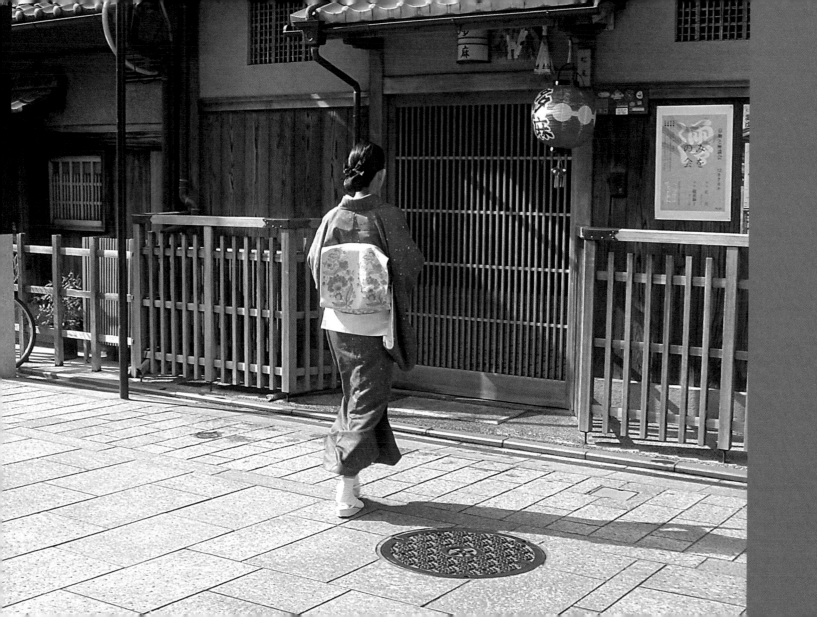

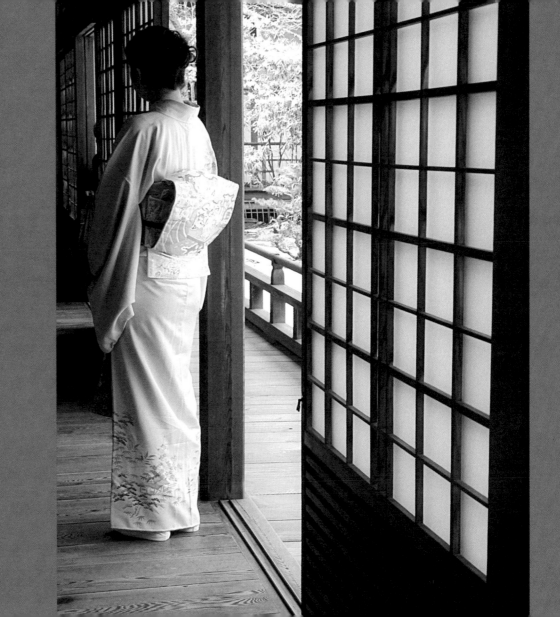

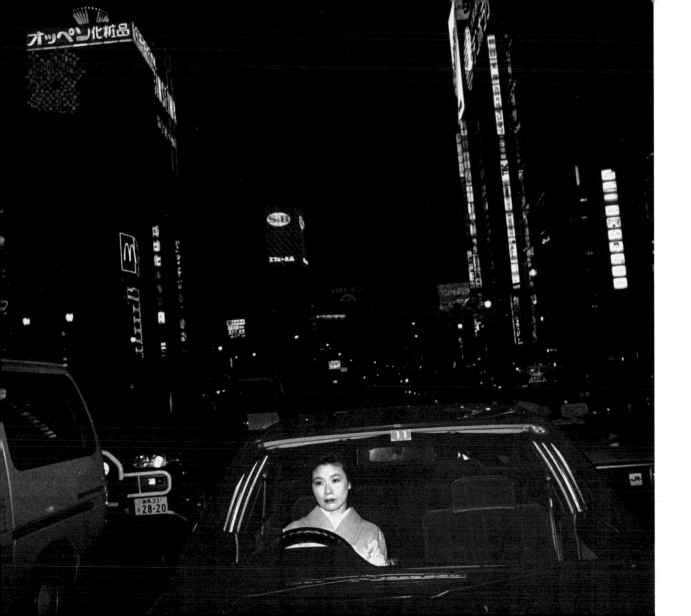

Nowadays, the kimono is mostly worn on special occasions—festivals, ceremonies—and very occasionally for the simple delight of the wearing. One is hard put to imagine today that once upon a time the entire Japanese people lived and worked in this unique, not especially functional garment. But we should remember that practical, comfortable clothing is a relatively recent idea. No nation and no ethnic group, whatever its history or its antiquity, has ever adopted a style of dress purely for its practical advantages. And this is especially true of Japan, where beauty has always won the day against simplicity and functionality.

wear a kimono

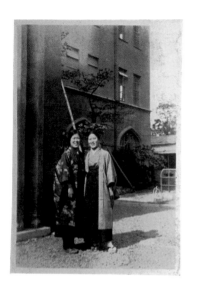

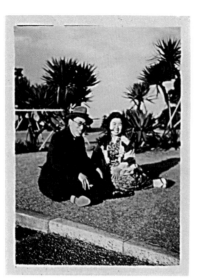

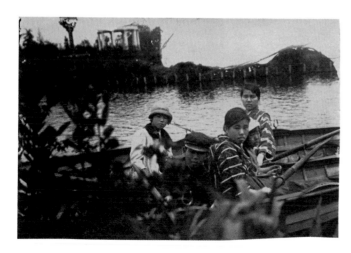

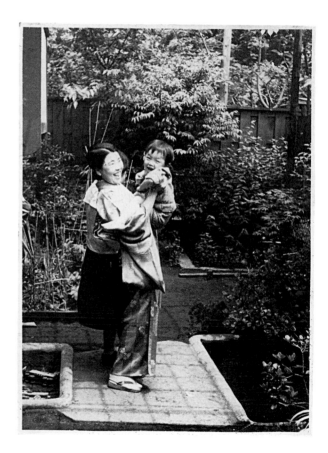

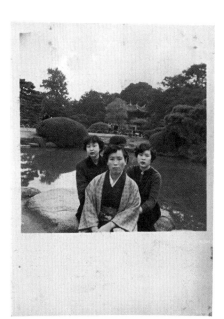

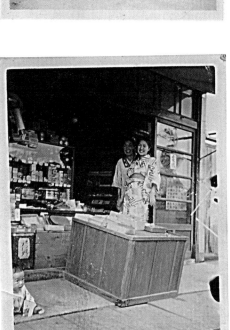

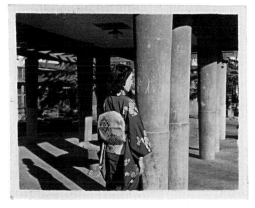

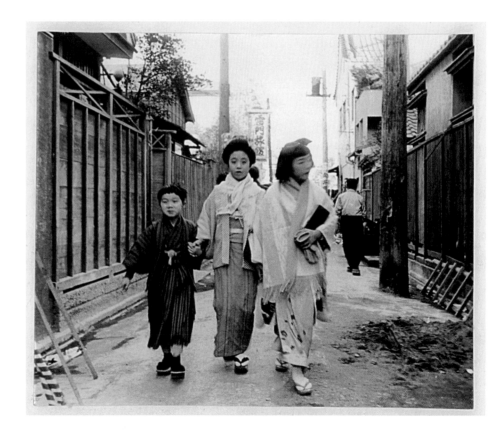

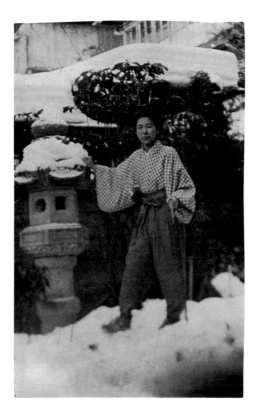

Working, walking, playing: until the early twentieth century the kimono remained the basic dress of daily activity in Japan. In the countryside, region by region, a few variations existed. Kimonos might be shortened to make movement easier; trousers might be worn under them or pulled on over them; or sleeves could simply be held back with a looped cord known as a *tasuki*. The *tasuki* was popular with city shopkeepers and anyone who had housework to do.

After Japan opened up to foreign trade in 1853, the Japanese gradually forsook the kimono in favor of Western fashions, which symbolized their arrival in the modern world. This development took several decades, and it was not till after World War II that Japanese dress was fully aligned with the attire of the rest of the world. Japanese men were the first to embrace the change, even though at the time, since no textile industry existed on the spot, Western clothes had all to be imported and therefore were very expensive. When Japanese lacked the means to dress in a completely Western style, they confined themselves to a few accessories. This led to a curious mixture of kimonos, fedoras, and lace-up shoes. For many years, men wore Western clothes to work and changed back into their kimonos when they got home, finding them better adapted to their living environment. Women, who stayed at home anyway, remained loyal to the kimono for much longer. The result was that the urban dress of Japan was for a while split along gender lines.

During World War II, at the request of their government, women cut their kimonos and turned them into working jackets, or *monpe*. Little by little, they sacrificed their wardrobes, first altering their least precious kimonos and leaving their silk, hand-painted heirlooms until last.

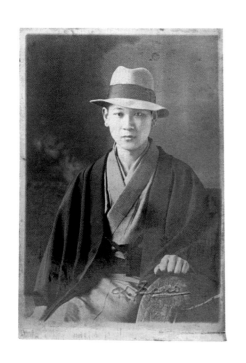
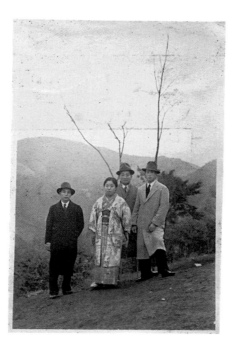
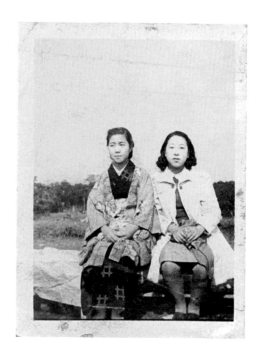

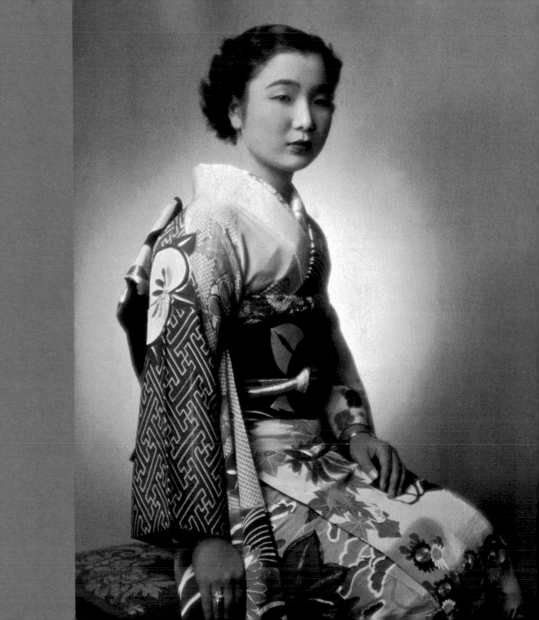

An item of Western dress is expected to "fall well." Its cut must be carefully gauged to fit the complex outlines of the human anatomy. By contrast the kimono, with its flat construction, does not sit naturally on the body. It must be correctly placed in order to fall well, and this requires both savoir faire and plenty of preparation. The art of kimono preparation is taught in schools, where you learn how to let the collar fall back to the most elegant effect; how to raise the kimono to exactly the right height above the ground; how to cross it to form a barely open V without hampering the movement of the neck; and how to align the front of it with the seam of the stocking on your right leg.

There are no clips or buttons on a kimono. It is held together by a succession of ties and belts culminating with an obi. Special knots are needed to keep these various elements exactly in place. There is no theoretical apprenticeship; only a chore of repetition, after which the various gestures of crossing, folding, and knotting can be memorized in their immutable order. The correct outline of the garment can be obtained only if these moves are carried out with absolute precision.

learn the ropes

Juban and *han'eri*

A kimono is never worn next to the skin, but over a *juban*, a kind of kimono made of much finer fabric. A white or printed stiff collar is affixed to the *juban*, which may be glimpsed within the outer collar of the kimono proper.

Tabi

These are socks with the big toe knit separately to accommodate the *zori*.

Zori

Thongs with wooden or plastic soles.

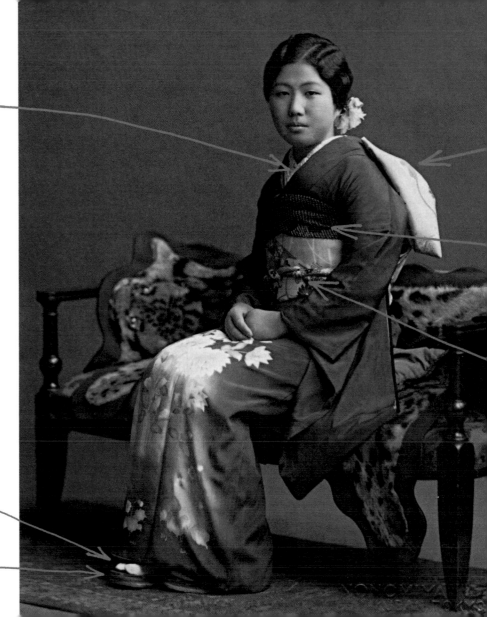

Obi

A broad belt that holds the kimono shut, knotted at the back in a number of different ways.

Obiage

A band of fabric that helps to keep the obi in place and also covers the *makuri* obi, a small cushion placed on the back to add volume.

Obijime

A cord used to keep the obi in place.

The kimono is not a garment that is worn in isolation but one that is accompanied by a whole range of accessories that will eventually make up the full outfit. Their purpose is to modify the silhouette in such a way as to approximate as closely as possible the Japanese feminine ideal. In the West, that ideal has always been an hourglass figure. In Japan, a perfect cylindrical tube is the goal.

Shaping elegant silhouettes with inhibited gestures and longing glances, the kimono lures the mind to imagine the most delightful undergarment. Nowadays, to achieve the tube effect and to immobilize the various elements of the kimono, Japanese women are taught by schools and books to flatten their bosoms with bras, hide their waists under several thicknesses of fabric, and harness themselves with belts and elastic bands. The result is more orthopedic equipment than exciting lingerie. Even men must submit; skinny ones are told to fill out their hollow abdomens, because a slight *embonpoint* is considered more becoming to a man with his obi settled at the hip. But these elements probably did not exist in the old days. Today's schools, which are the sole repositories of kimono savoir faire, seem to have caught the wearing of kimonos in a kind of stranglehold. The tackle used may keep the kimono impeccably straight, but it sacrifices the slight imperfections that were so enchanting in the dress of the past, those discreet dishevelments that one can still see in the *tenue* of female stars in old Japanese films.

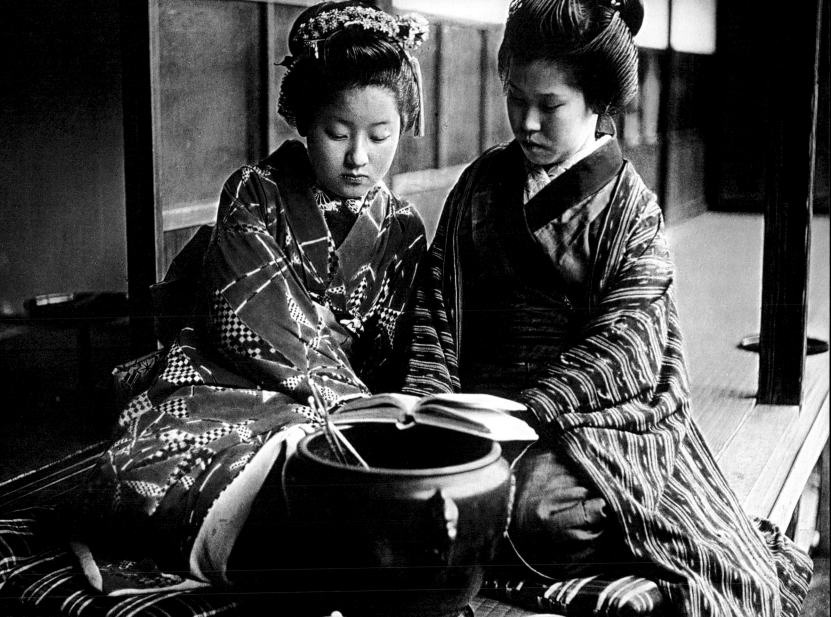

One element, the most important undergarment, has been passed on unaltered; this is the *juban*. The *juban* is curiously similar to the kimono and functions as a kind of lining. Being awkward to keep clean, a kimono is protected as far as possible from direct contact with the body. But the *juban* for all that is a lining which remains partly visible and which must be in exact harmony with the kimono in size, color, and fabric. Light cotton or linen is preferred in summer, layered silk in winter.

The sleeves of the *juban* are in exact proportion to those of the kimono, never spilling out or creating unsightly creases. At the same time, its motifs are discreetly visible through the back opening.

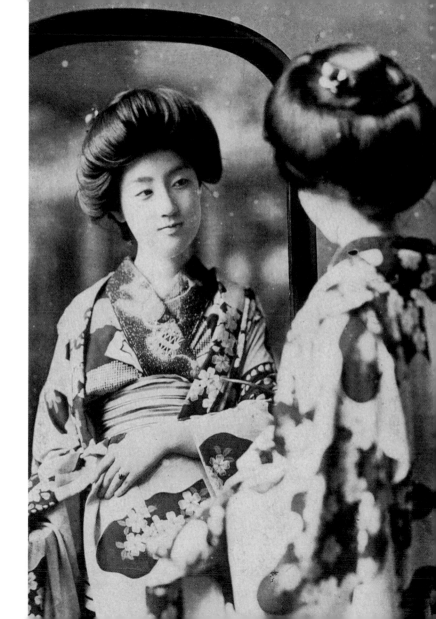

The neck, or collar, is the most important feature of the *juban*. It is invariably covered by a strip of fabric loosely stitched and easily removable for washing. Thus one can play with different colors and motifs and use the fact that it is clearly visible in the front opening of the kimono to create different associations.

The collar should be adjusted slightly back from the nape of the neck. The hair should not cover it and should be put up or cut short. The collar is rigidly reinforced to create a kind of buffer against which the kimono can rest. Without this buffer, the kimono could never achieve the backward fall that bares the nape, which Japanese men find extraordinarily sexy.

Only once the *juban* is properly in place, can the kimono be put on, then fine-tuned around the neck and waist. Its hem begins by touching the ground; it must be raised just enough to brush against the stockings. For this, a fold (*obashiori*) must be made with the surplus length, to protrude ever so slightly from the obi. All of this is held in place with ties and elastic clips. Finally, just before the obi is put on, a cardboard stiffener is added to give rigidity to the waistline. The *obashiori* is probably a relic from much older ways of knotting the kimono. In the past, it was attached in a flexible way; the upper works of the kimono overflowed over the sash and partly obscured it. The obi then came in to cover everything, leaving only a single fold showing.

Contemplating the marvelous designs of antique *juban*, one imagines that these undergarments must have had a charm that has ceased to exist today—and that the discipline taught in the modern schools has effectively stifled the inherent eroticism of the kimono.

Is the kimono erotic?

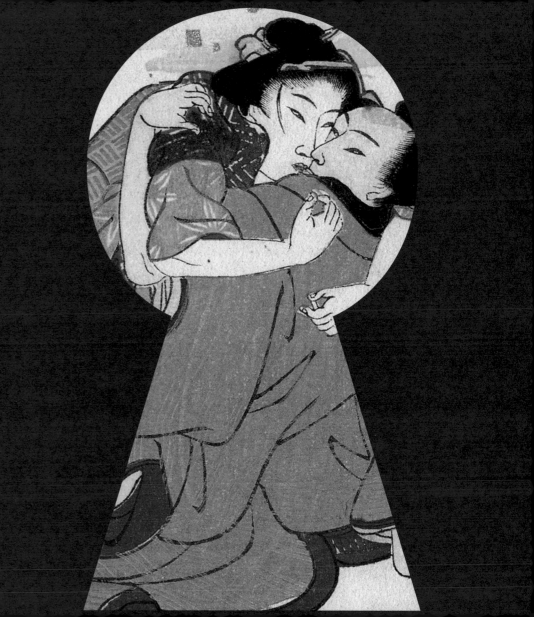

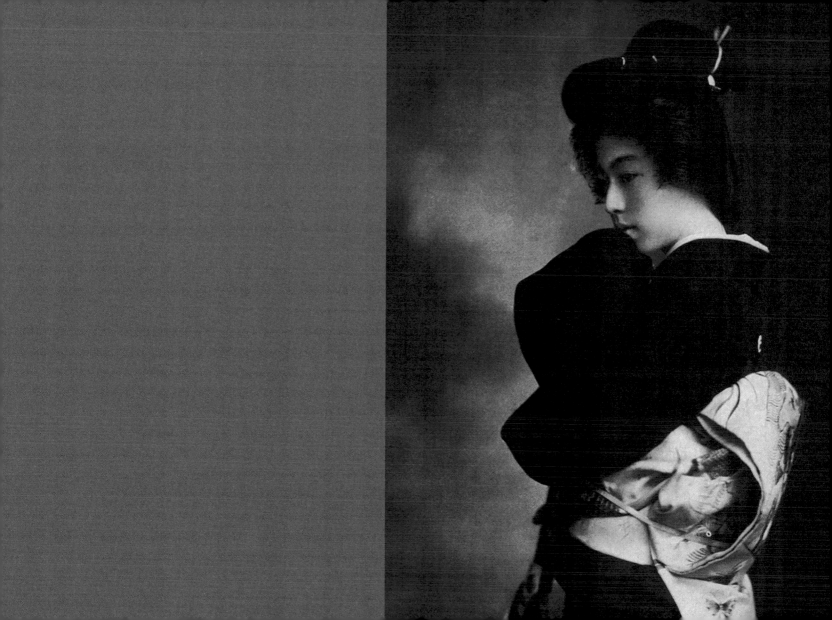

obi
variations

maru obi and fukuro obi 32 cm x 420 cm (12⅝" x 13¾')

nagoya obi 75/30 cm x 360 cm (29½/11⅞" x 11⅞')

han haba obi 15 cm x 360 cm (5⅞" x 11⅞')

The general term "obi" covers the different types of sashes that can be used with a kimono. It is difficult to make a simple classification of these because each one has a specific name that corresponds to variations of form, length, width, or fabrication, and even of all of these elements at the same time. Today, the most used forms of obis are, in descending order of formality: *maru* obi, *fukuro* obi, *nagoya* obi, and *han haba obi*.

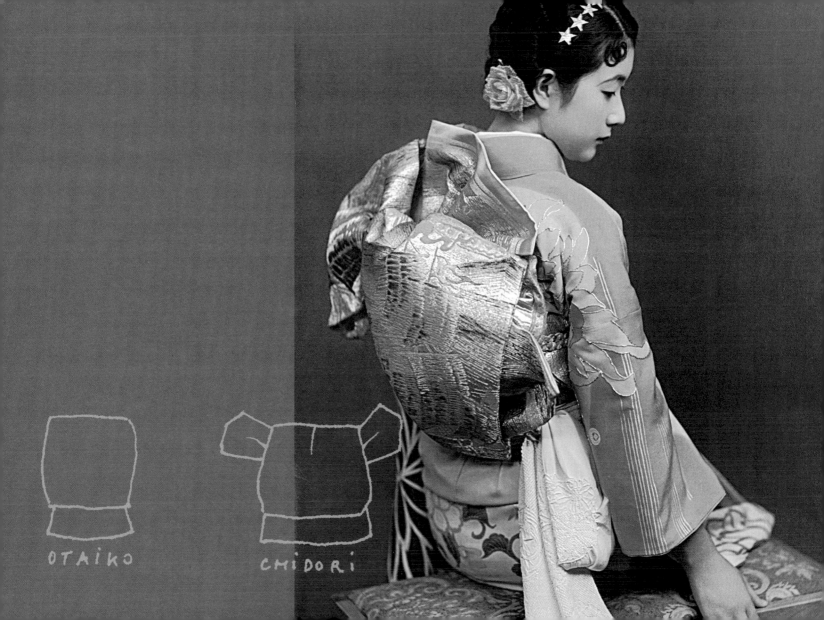

OTAIKO

CHIDORI

Obis can be knotted in many different ways. These simple sashes can be transformed by the use of cunning folds to represent flowers or insects.

Scholars have identified up to three hundred different types of knots, although very few of them are still in use today. At the start of the Edo period, the obi was casually knotted in front, at the side, or behind. It was not until the early eighteenth century that the knot was systematically placed in the back. In effect, the width of the obi having increased from five to thirty centimeters (two to twelve inches), it had become highly inconvenient to have so enormous a knot in front.

As usual in Japan each knot is reserved for use in one or more very precise situations. Thus the *tateya* or the *chidori* are restricted to unmarried girls, while the *otaiko*, which is visually much simpler, is the preserve of married women. The *otaiko* is the most commonly worn knot today, its sober cushion nonetheless complicated to achieve.

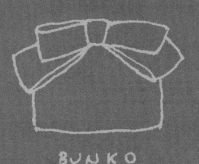

BUNKO

KAI-NO-KUCHI

TATEYA

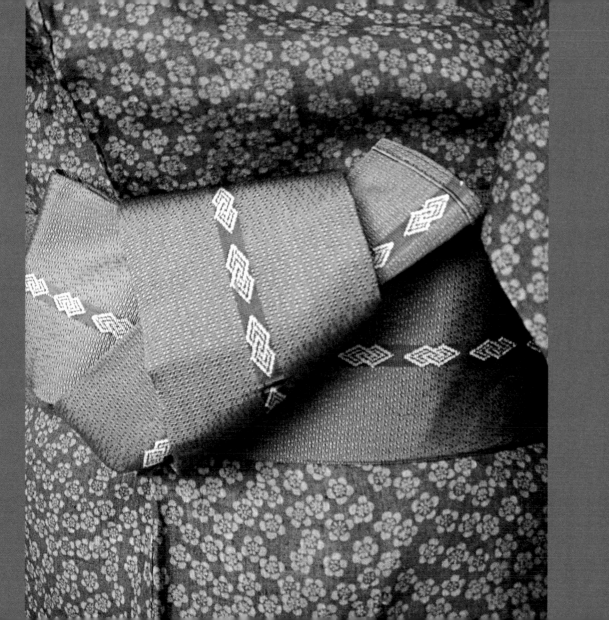

For men, there is only one kind of obi. Their sash is narrow and worn above the hips; the knot itself, being the only one available, has no function signifying degrees of formality, as do the women's obis. However, a man acknowledges a special occasion such as a tea ceremony, a wedding, or a funeral by wearing a *hakama* over the kimono.

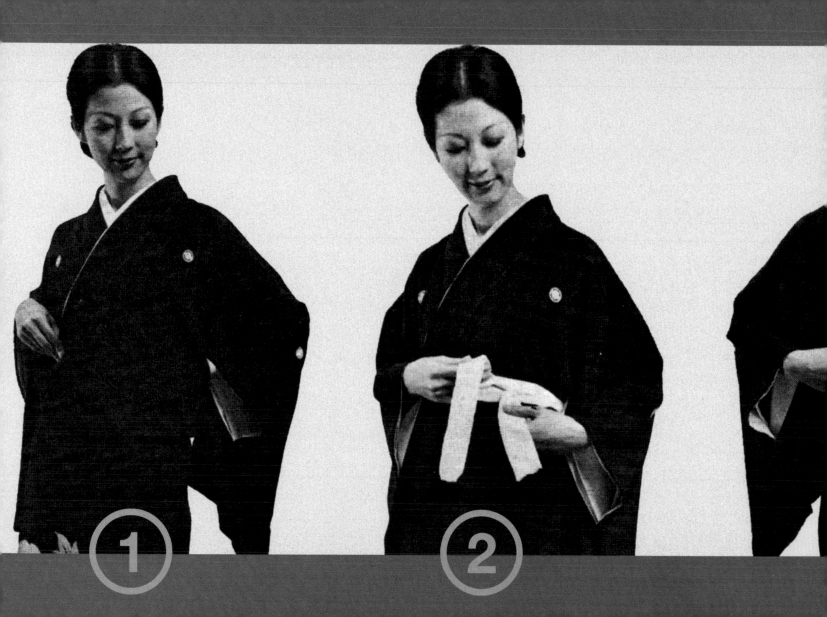

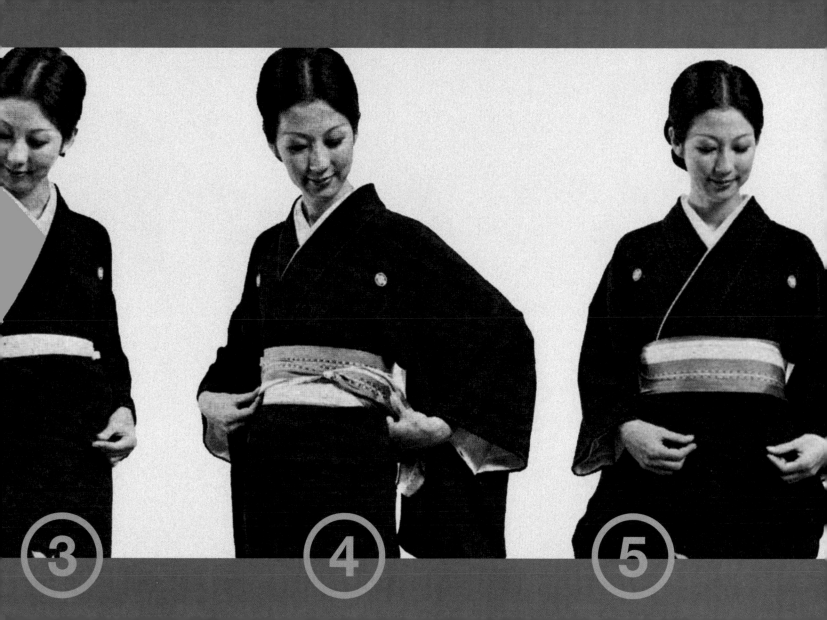

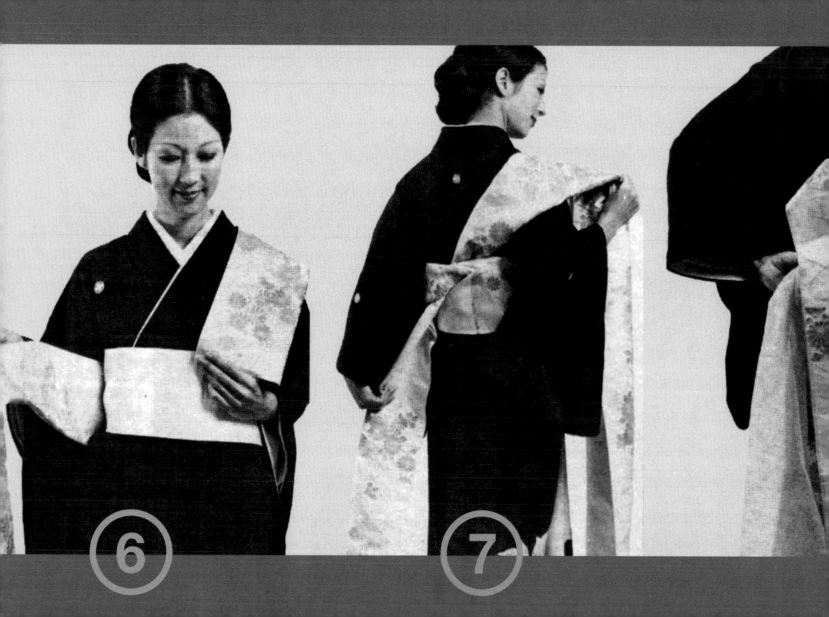

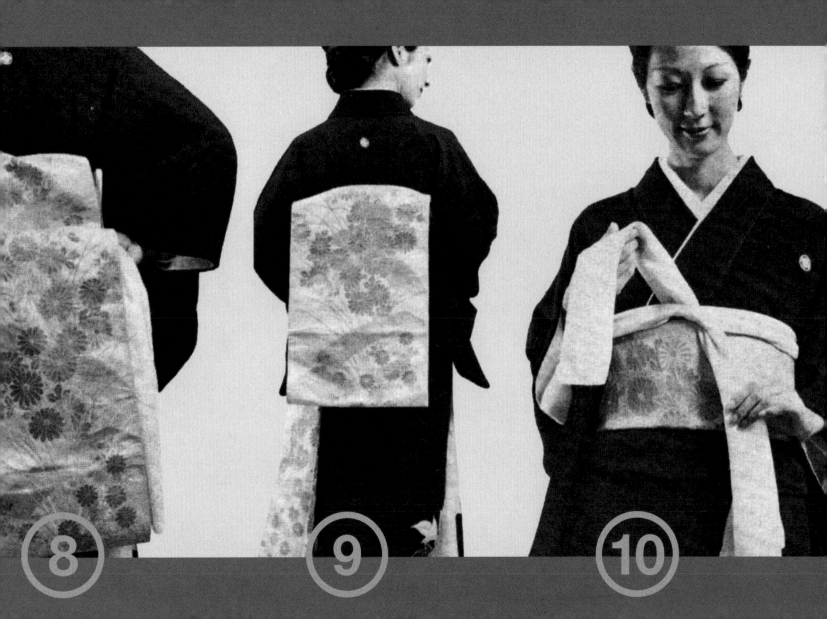

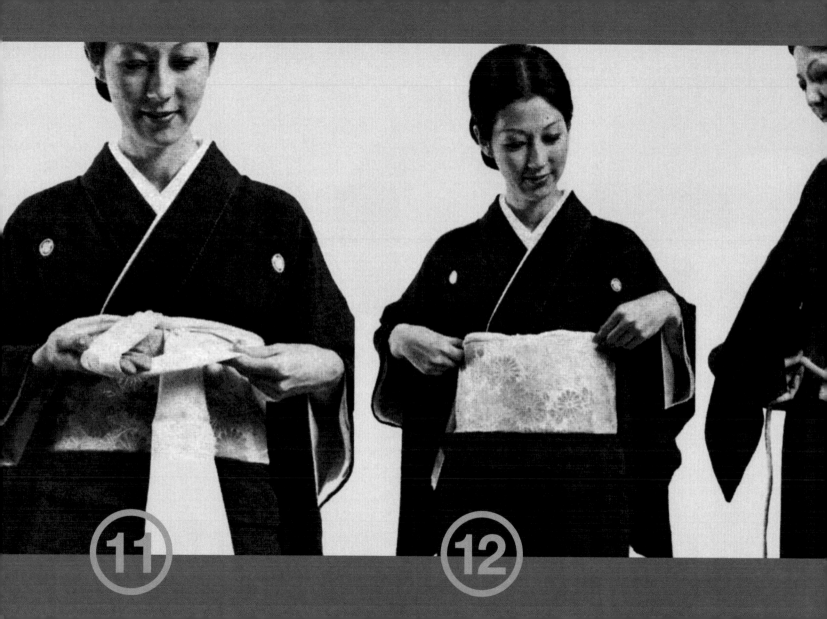

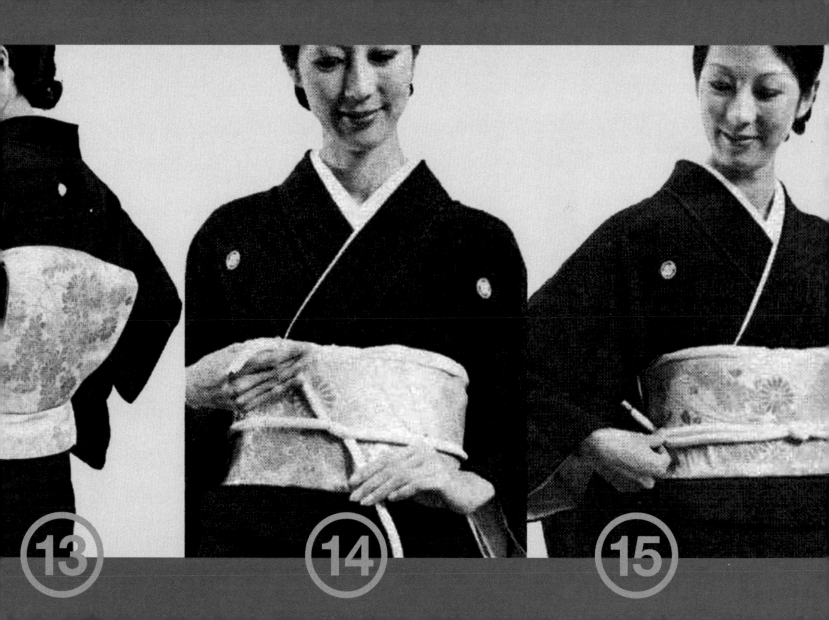

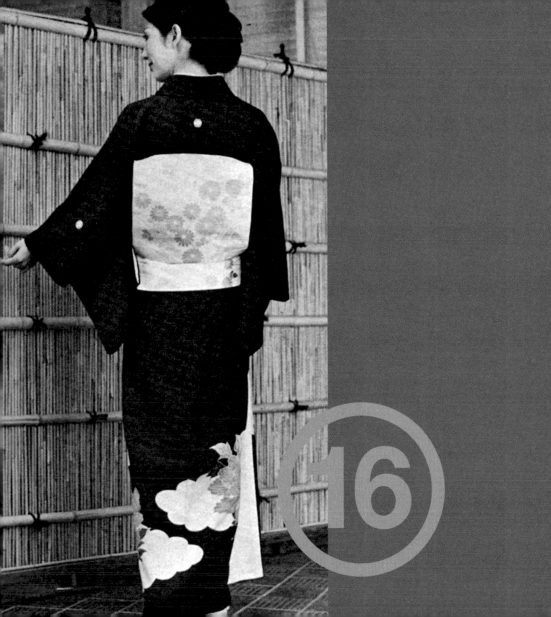

It is extraordinarily difficult to master the proper way of wearing a kimono and the correct tying of obis. Neither can be improvised, and their secrets are not necessarily transmitted from mother to daughter. Special schools in Japan offer courses and diplomas on these subjects, in which you mainly learn to avoid lapses of taste that, should you commit them, would forever stigmatize you in the eyes of Japanese womanhood. For example, you must understand that brightly colored kimonos are exclusively for young, unmarried women; that a woman is expected to dress in shades gradually more discreet as she grows older; that the *osode*, a long-sleeved kimono, is inappropriate for a married woman; that the *obijime* cord that holds the *obi* in place should be tied at a predetermined height, according to the age of the wearer; and finally, that the colors and motifs of the kimono should reflect those of the season, or even be slightly ahead of it—this being the sign of a particularly refined sensibility and taste. On the other hand, by making the kimono an object of academic study, schools like these have a tendency to consign it to a mannered and inert style.

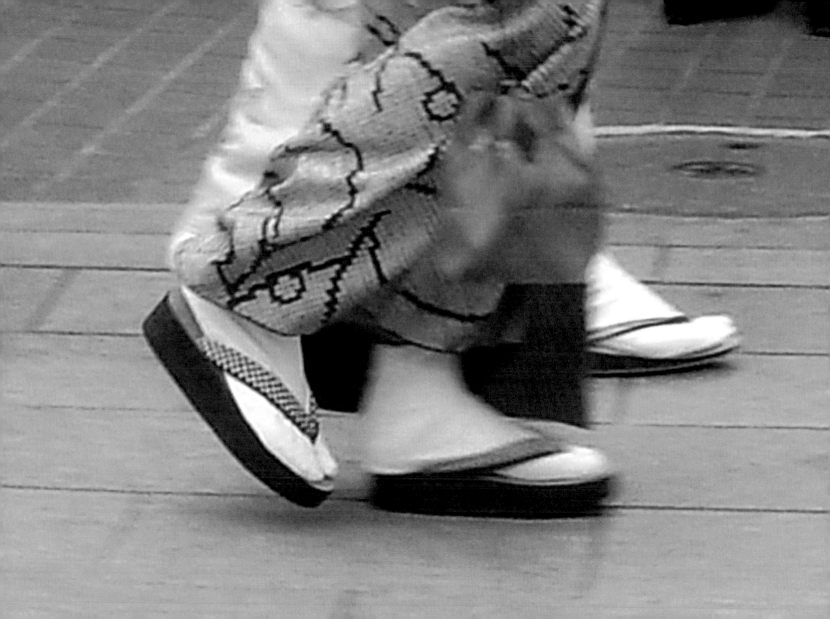

tabi, zori, and geta...

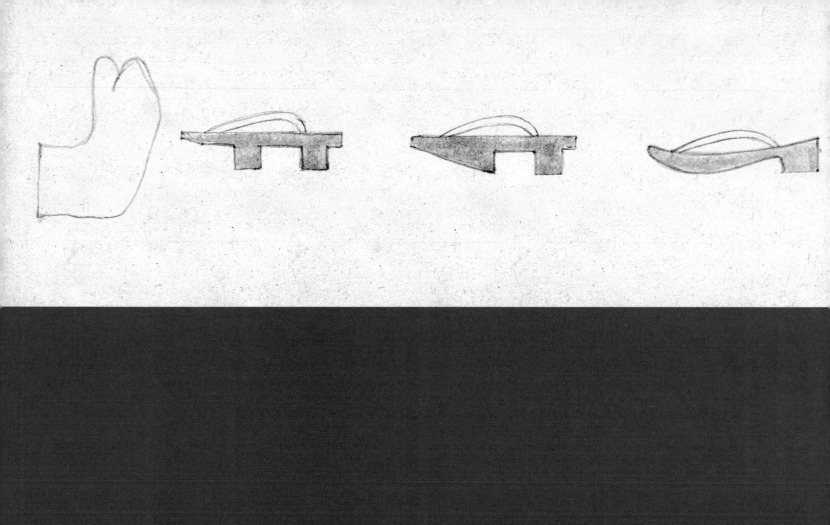

The costume of the perfect Japanese woman would not be complete without *tabi*, *zori*, and *geta*. *Tabi* are canvas socks with a space between the toes that make it possible to wear Japanese thonged sandals, known as *zori* or *geta* according to the shape and material of their soles. *Zori* have full soles and can be made of vinyl or plaited straw. *Geta* are made of wood, are often higher, and can be worn without stockings in the summer. They are also used for less formal occasions.

The soles of both *geta* and *zori* are rounded for women and squared for men, a distinction that corresponds to the symbolic representation of the two sexes in Japanese culture. The laces are often made of cloth and offer a wide choice of motifs and materials.

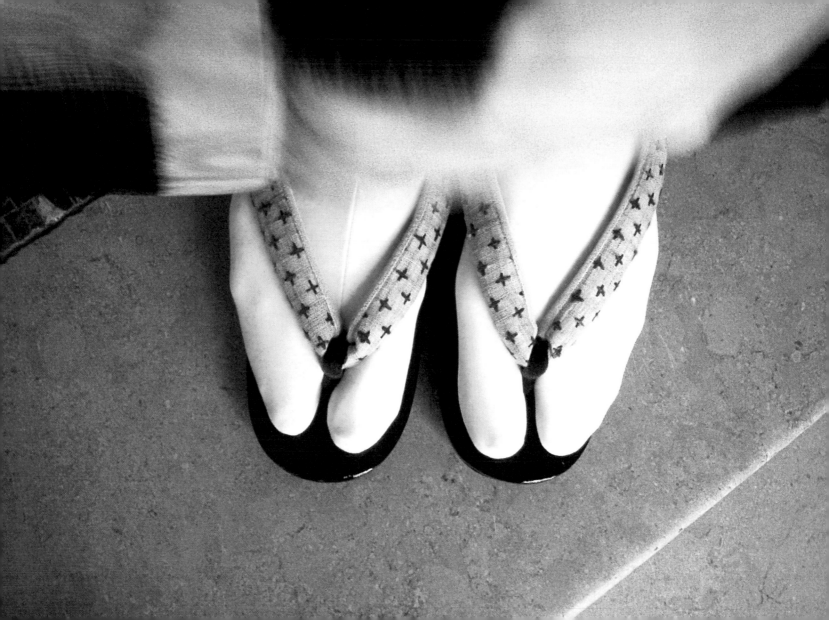

Geta and *zori* give Japanese women their unique gait of short, slightly dragging steps, with the feet turning slightly inward.

Tabi are usually white for women and black for men, but they can also be printed with special motifs. Younger women seem to appreciate this most, since it gives them a chance to add a note of fancy. In Japan, the sock is not something to be concealed, as it often is in the West. Department stores are full of extravagant models, and Japanese girls don't hesitate to wear them with short skirts and high-heeled shoes.

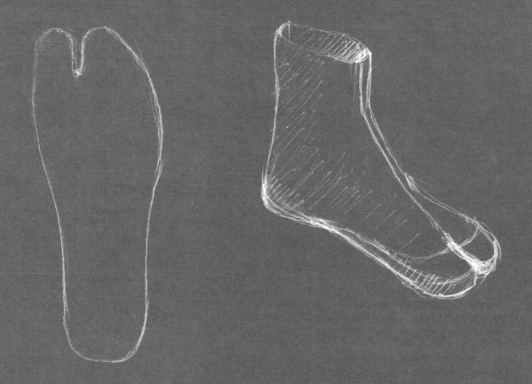

For a hundred years, Japanese farmers have worn peculiar little boots called *jika tabi*. Workers on building sites also wear them with voluminous billowing trousers. *Jika tabi* are a kind of cross between *tabi* and rubber boots. It is amazing to see how the addition of a simple rubber sole can turn a pair of socks into a pair of shoes.

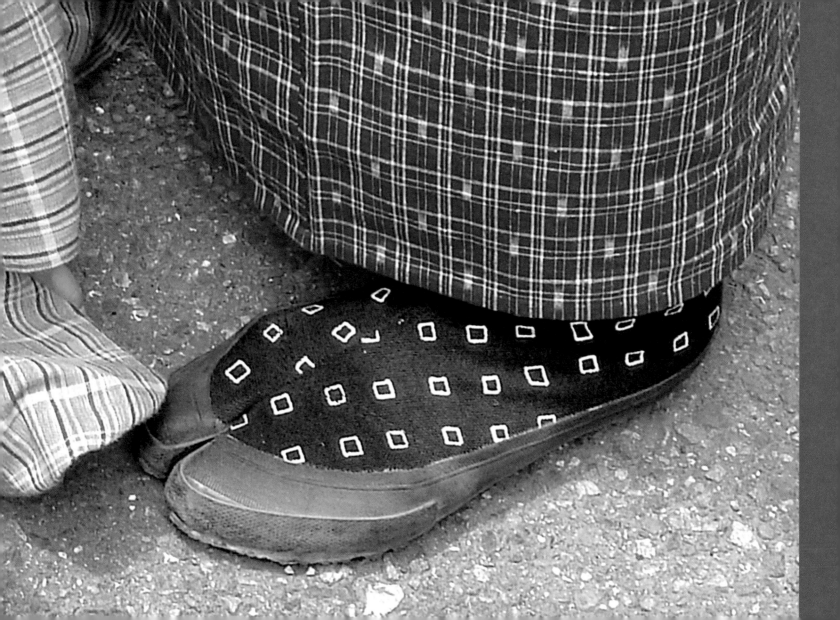

With each new season, the Belgian fashion designer Martin Margiela offers a new collection of shoes that are variations on the theme of the *tabi*. It seems that for him, too, *tabi* are not ordinary socks to be hidden away, and that with a few changes of material they can easily achieve the status of shoes.

The fragility of *tatami* mats probably explains the ancient Japanese habit of wearing nothing but socks on the feet indoors. Besides, *zori* and *tabi* aren't exactly the equivalent of Western shoes and socks but rather complete shoes whose soles happen to be removable. In Japan, taking off one's shoes is not felt to be an intimate gesture; in the old days it was customary even in the imperial household. *Zori* were formerly well adapted to this practice, answering to the Japanese guiding principle of clearly separated indoor and outdoor spheres. Today, Japanese houses still have a chest at the entrance for shoes, which marks the frontier between the two. And though the Japanese no longer wear *zori* or *geta* as everyday footwear, they still take off their shoes in modern apartments, certain restaurants, and offices.

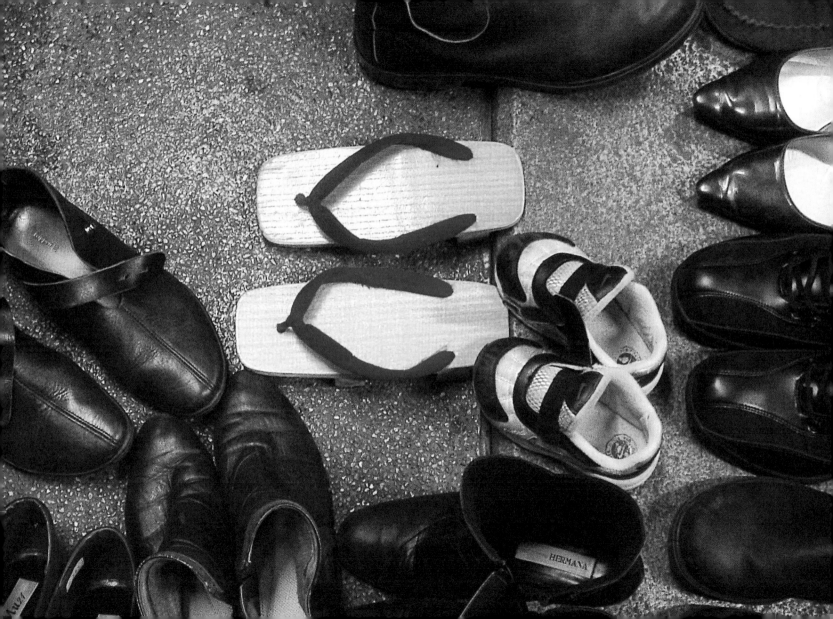

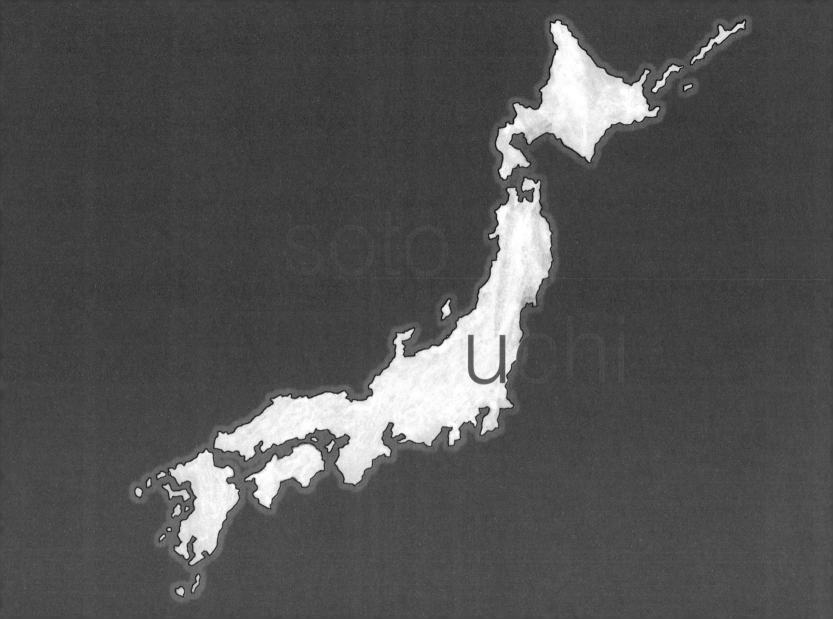

The concept of outside and inside is called *soto/uchi* in Japan. It may mean the outside and inside of a place or a house but may also refer to the insularity of Japan itself, clearly distinguished from the rest of the world. Their geographical circumstances give the Japanese the certainty that they are radically different from other nations, a conviction reinforced by long periods of isolation in their history during which their island developed a rich culture of its own and a strong sense of national unity. More foreigners now live in Japan than ever before, but still they are relatively few in number. The population is extremely homogenous and the *gaijin* one meets from time to time always give the impression, in spite of themselves, of "breaking the harmony." The Japanese are not actually hostile to foreigners, but they are imbued with a certain pride from knowing what it really means to "be Japanese."

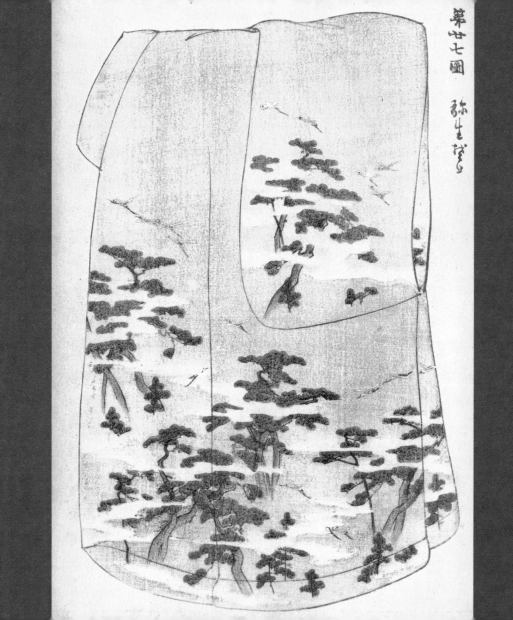

It is very difficult for me, after spending two years in Japan, to assess exactly what I know today about the country. But is that really important? My goal at the start was not so much to acquire encyclopedic knowledge of the place as to be nourished by it. I looked at it with my own eyes. To go after objectivity would have been futile, so I sought above all to be touched by the experience.

Japan gave me deep nourishment. It also upset and unbalanced me from time to time. But such difficulties have their own importance in any creative work. One looks for the quake areas, for the isolation that is necessary to reflection. One wants to be on the sidelines, not in the full flow. Japan was the perfect place for me at that time.

captions

p. 4: Drawing of a kimono, antique catalogue. Collection Sophie Milenovich.

p. 6: Yohji Yamamoto cutting into a pattern.

p. 9: Tokyo, 2006.

p. 11: Photograph by Hamaya Hiroshi.

p. 12: Photograph by Nobuyoshi Araki.

pp. 14–15: Photograph by Nobuyoshi Araki.

p. 16: Photograph by Hamaya Hiroshi.

p. 19: *Meisen* kimono dating from the 1940s or 50s. Collection Sophie Milenovich. *Meisen*, a weaving method used to make cheap kimonos, was very popular in the first half of the twentieth century.

p. 20: *Meisen* kimono dating from the 1920s or 30s. Collection Sophie Milenovich. Model: Aya; makeup and hair styling: Hiroko Sunanaga.

p. 23–24: *Meisen* kimono dating from the 1920s or 30s. Collection Sophie Milenovich. Model: Aya; makeup and hair styling: Hiroko Sunanaga

p. 29: *Meisen* kimono dating from the 1930s. Embroidered silk obi dating from the 1920s or 30s. Collection Sophie Milenovich. Model: Aya; makeup and hair styling: Hiroko Sunanaga.

p. 30: *Meisen* fabric bolt dating from the 1930s. Collection Sophie Milenovich.

p. 32: Kimono fabric store, Asakusa, Tokyo.

p. 35: Child's cotton kimono dating from the 1930s or 40s. Collection Sophie Milenovich.

pp. 36–37: Kimonos dating from the 1920s or 30s. Collection Sophie Milenovich.

p. 38: Printed silk kimono dating from the 1940s. Obi dating from the 1930s or 40s. Collection Sophie Milenovich. Model: Aya; makeup and hair styling: Hiroko Sunanaga.

p. 45: Kimono dating from the 1930s or 40s. Cotton obi dating from the 1930s.

p. 46: *Meisen* kimono dating from the 1940s or 50s. Obi dating from the 1950s. Collection Sophie Milenovich. Model: Aya; makeup and hair styling: Hiroko Sunanaga.

pp. 48–49: Katsushika Hokusai. *Five Beauties*, Hosomi Museum, Kyoto.

p. 50 (left): Kitagawa Utamaro. *A Beauty Blowing on a Poppin*, from *Ten Physiognomatic Aspects of Women*, c. 1791. Honolulu Academy of Arts. Gift of James A. Michener.

pp. 50–51 (center): Kimono textile. Collection Sophie Milenovich.

p. 51 (right): Édouard Vuillard. *La ravaudeuse*, c. 1891–92. Musée d'Orsay, Paris.

p. 53: Pierre Bonnard. *Le peignoir*, c. 1892. Musée d'Orsay, Paris.

p. 54: Modeling for Madeleine Vionnet. Musée des Arts Décoratifs, Musée de la Mode et du Textile, Paris.

p. 55: Drawing of a Madeleine Vionnet pattern from 1920 by Miguel Cistera and Myriam Tessier. Musée des Arts Décoratifs, Musée de la Mode et du Textile, Paris.

p. 56: *Madeleine Vionne Dress, Longchamp, Avril 1922*. Photograph by Séeberger Frères. Bibliothèque Nationale de France, Paris.

p. 58: Madeleine Vionnet, *Harper's Bazaar*, October 1934.

pp. 62–63: Yohji Yamamoto Spring/Summer 2000 Collection, "Model 8," front and back.

p. 64: Alfred H. Maurer. *Young Woman in Kimono*, 1901. Corcoran Gallery of Art, Washington, D.C. Gift of Edith Newlands Johnston and Janet Newlands Johnston.

p. 67: Alfred Stevens. *La Parisienne japonaise*, c. 1871–75. Musée d'Art Moderne et d'Art Contemporain, Liège.

p. 68: Gustave Courtois. *Etude*, 1890. Art Gallery of New South Wales, Sydney.

p. 70: Young boy's printed silk kimono dating from the 1920s. Collection Sophie Milenovich.

pp. 72–76: Kimono fabric pieces dating from 1890 to 1950. Collection Sophie Milenovich.

p. 79: Princess Hisako in her *juni-hitoe* (twelve-layer) wedding kimono.

p. 80: Silk screen illustrated with a *kosode* printed with flower hats. National Museum of Japanese History, Tokyo.

p. 81: Silk *kosode* with wood-sorrel-in-circles motifs.

p. 82: Antique catalogue displaying *komon*-like motifs. India ink on paper. Collection Sophie Milenovich.

p. 83: From an antique kimono catalogue. Collection Sophie Milenovich.

p. 84: After Margarita Winkel. *Souvenirs from Japan*, 1991. Private collection, Switzerland.

pp. 86–87: Utagawa Hiroshige. *Mikaeri Yanagi* (Gazing Back Willow Tree), from *One Hundred Famous Views of Edo*, 1853. Musée Guimet, Paris.

p. 88: Kimono fabric dating from the 1920s. Collection Sophie Milenovich.

pp. 91, 94, 96, 102, 103: Kamakura, 2005.

pp. 92, 93, 97, 99, 101, 104, 107, 110–121, 135–139: Tokyo, 2005–2006.

pp. 100, 108, 109, 125, 128, 140, 141: Kimonos, obis, *haori*, and accessories, Tokyo, 2006. Collection Sophie Milenovich.

pp. 122, 124, 126, 129, 130, 131, 133: Kyoto, 2005–2006.

p. 142: Nara, 2006.

p. 144: Embroidered obis dating from the 1920s.

pp. 147–67, 169–73: Tokyo, 2005–2006.

p. 168: Drawing of a wedding kimono, antique catalogue. Collection Sophie Milenovich.

pp. 175–79, 183: Kyoto, 2006

p. 180: Kyoto, 2005.

p. 184: Photograph by Issei Suda.

pp. 186–93: Early photographs, photographers unknown. Collection Sophie Milenovich.

p. 194: Photograph by Iwata Nakayama.

p. 196: Early photograph, photographer unknown. Collection Milen Milenovich.

p. 199: Geishas Kodamasan (left) and Yobokichi in Beppo on Kyushu Island, reading a book belonging to their guest Waldemar Abegg, 1906.

p. 200: Early photograph, photographer unknown.

p. 202: *Juban* dating from the 1930s. Collection Sophie Milenovich.

p. 205: *Shunga* (erotic print) dating from the 1920s, artist unknown. Collection Milen Milenovich.

p. 206: Early photograph, photographer unknown.

p. 210: Photograph by Iwata Nakayama.

p. 212: A man's kimono and obi dating from the 1930s. Collection Sophie Milenovich.

pp. 214–20: Handbook teaching the proper tying of an obi, dating from the 1960s. Collection Sophie Milenovich.

p. 222: Kamakura, 2005.

pp. 224–25: Drawing by Sophie Milenovich.

p. 226: Contemporary *zori*. Collection Sophie Milenovich.

p. 229: Tokyo, 2005.

p. 231: Martin Margiela slippers, Tokyo, 2005.

p. 233: Entrance of a *ryokan* (traditional inn), Kurashiki, 2006.

p. 236: Drawing of a kimono, antique catalogue. Collection Sophie Milenovich.

photo credits

The author would like to thank Edith Bellod, Françoise Cousin,
Albane Ducros, Stéphanie Grégoire, Marie-Claire Meunier, Milen,
Oscar and Victor Milenovich, Sakata Sensei, Hiroko Sunanaga,
Aya Watanabe, and especially Géraldine Kosiak, for their friendship
and precious help in this project.

acknowledgments